COLLINS • Learn to paint

Outdoors in Watercolour

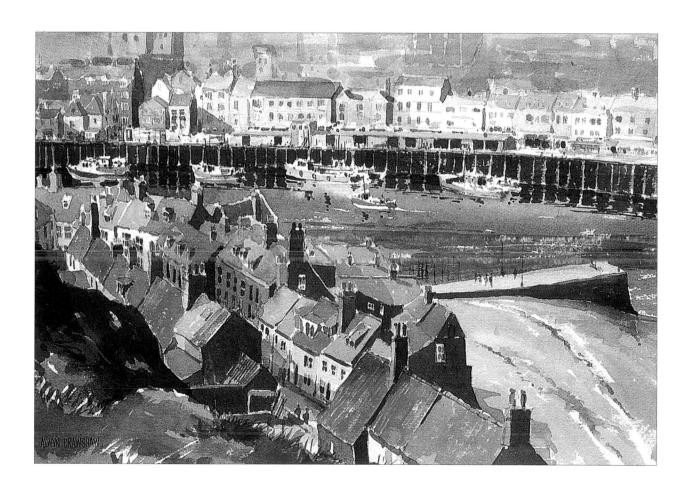

ALWYN CRAWSHAW

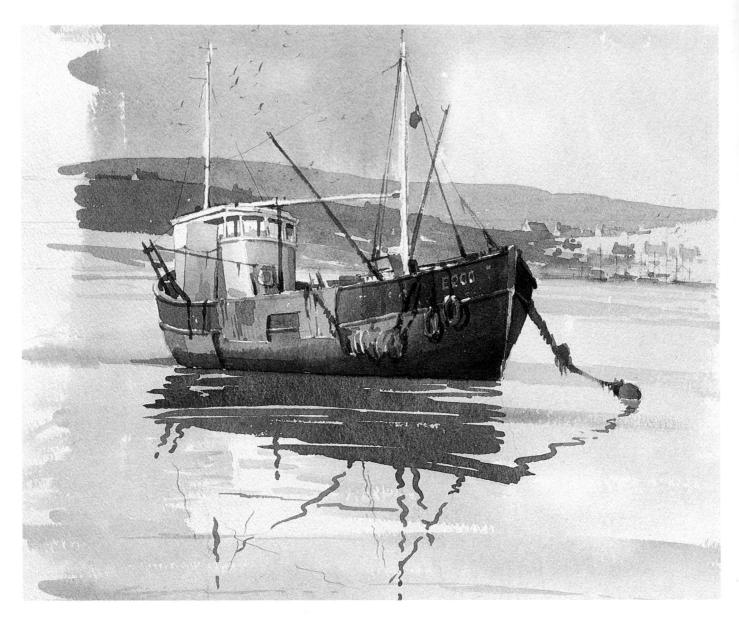

HarperCollinsPublishers 77-85 Fulham Palace Road Hammersmith London W6 8JB

The HarperCollins website address is www.fireandwater.com

Collins is a registered trademark of HarperCollins Publishers Limited

First published in 1986 by William Collins Sons & Co Ltd, London Reprinted 1987, 1988, 1989, 1990 (twice) Reprinted by HarperCollins*Publishers*

> 00 02 04 03 01 12 14 16 17 15 13

© Alwyn Crawshaw 1986

Alwyn Crawshaw asserts the moral right to be identified as the author of this work

Designed by Caroline Hill Photography by Michael Petts

All rights reserved. No part of this publication may be reproduced, stored in a retrieval system, or transmitted, in any form or by any means, electronic, mechanical, photocopying, recording or otherwise, without the prior written permission of the publishers.

A catalogue record for this book is available from the British Library

ISBN 0 00 413345 5

Printed and bound by Printing Express, Hong Kong

CONTENTS

Portrait of an artist Alwyn Crawshaw SEA, BWS, FRSA	4	Finding a painting spot and when to finish a picture	40
The excitement of painting outdoors	6	Composing a picture	42
What equipment do you need?	10	Recording your holiday	44
What can your brush do?	14	Exercise one	48
Drawing exercises with a brush	18	Crockenwell	
Exercises using three colours	22	Exercise two River Otter	52
Half-hour exercises using six colours	26	Exercise three Fountains Abbey	54
Working over pencil on cartridge paper	28	Exercise four Fishing boat	56
Simplifying nature	30	Exercise five The lock	60
Using pen and wash	38	Do's and don'ts	64

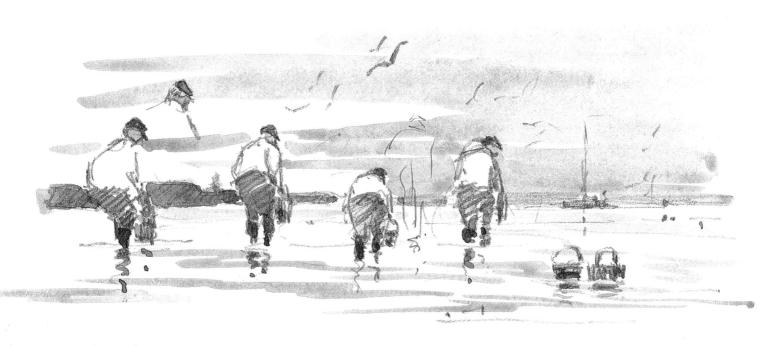

PORTRAIT OF AN ARTIST

ALWYN CRAWSHAW

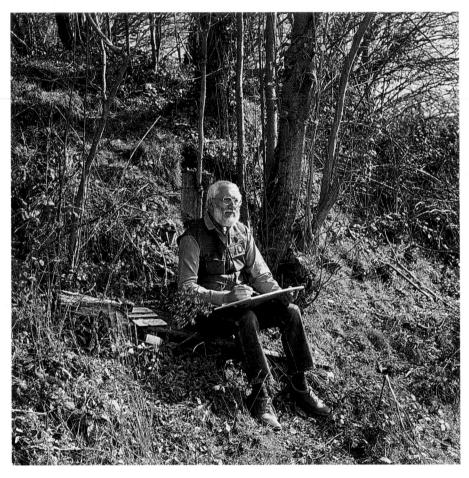

Fig. 1 Alwyn Crawshaw painting outdoors

Successful painter, author and teacher, Alwyn Crawshaw was born at Mirfield, Yorkshire and studied at Hastings School of Art. He now lives in Dawlish, Devon with his wife June where they have opened their own gallery. Alwyn is a member of the Society of Equestrian Artists and the British Watercolour Society, a Fellow of the Royal Society of Artists, and is listed in the current edition of *Who's Who in Art*. His work has brought him recognition as one of the leading authorities in his field.

As well as painting in watercolours, Alwyn also works in oils, acrylics and pastels. He chooses to paint landscapes, seascapes, buildings and anything else that inspires him. Heavy working horses and elm trees are frequently featured in his paintings and may be considered the artist's trademark.

This book is one of eight titles written by Alwyn Crawshaw for the HarperCollins *Learn to Paint* series. Alwyn's other books for HarperCollins include: *The Artist at Work* (an autobiography of his painting

career), Sketching with Alwyn Crawshaw, The Half-Hour Painter, Alwyn Crawshaw's Watercolour Painting Course and Alwyn Crawshaw's Oil Painting Course.

Alwyn's best-selling book A Brush with Art accompanied his first 12-part Channel Four television series. A second book, Crawshaw Paints on Holiday, accompanied his second 6-part Channel Four series, and Crawshaw Paints Oils, is the third Channel Four television series with a tie-in book of the same title. In addition, Alwyn has been a guest on local and national radio programmes, and has appeared on various television programmes. Alwyn has made several successful videos on painting and in 1991 was listed as one of the top ten artist video teachers in America. He is also a regular contributor to Leisure Painter magazine. Alwyn organises his own successful and very popular painting courses and holidays as well as giving demonstrations and lectures to art groups and societies throughout Britain.

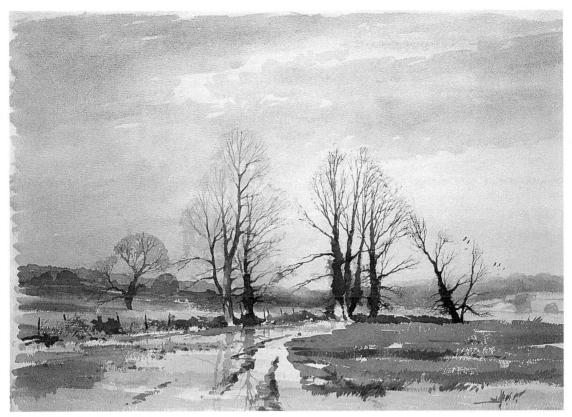

Fig. 2 After the Heavy Rain

Fine art prints of Alwyn's well-known paintings are in demand worldwide. His paintings are sold in British and overseas galleries and can be found in private collections throughout the world. Painted mainly from nature and still life, Alwyn's work has been favourably reviewed by the critics. *The Telegraph Weekend* Magazine reported him to be 'a landscape painter of considerable expertise' and *The*

Artist's and Illustrator's Magazine described him as 'outspoken about the importance of maintaining traditional values in the teaching of art'.

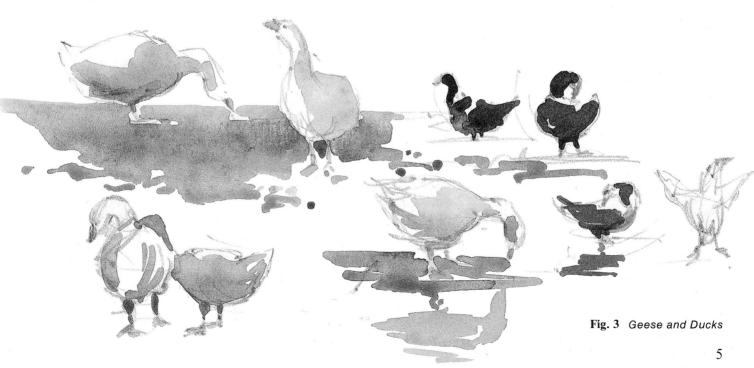

THE EXCITEMENT OF PAINTING OUTDOORS

The tremendous pleasure and excitement that you can get from painting outside, I believe, comes from the knowledge that there is a never-ending range of subjects to paint. There is something for everybody – from a simple pebble on the beach to a breathtaking view over miles and miles of enchanting landscape. In addition to this marvellous choice of subjects – and what makes painting out of doors so special – is the fact that each is enhanced by nature's 'mood', which can vary so much from one moment to the next, according to the kind of day it is.

If you are of an artistic nature, even if you have never painted before, you must have experienced at some time, for instance, the smell of blossom in the air on a beautiful spring morning and felt inspired to express your feelings in some tangible form. What better way to do this than to paint a picture! A manmade landscape can be just as stimulating. Just think of the times you have been in a town or city on a hot

day, with everybody dressed in brightly coloured summer clothes and the sun dancing on and off the shiny surfaces of the cars and buses as they move about, their shadows emphasizing the brilliance of the sunlit areas.

Unfortunately, however, it is not always possible to sit down and paint whenever you are inspired. I can recall an occasion when, during the Christmas holiday, I went with my family for a walk along the river bank and came across a scene that would have made a perfect watercolour painting. It was late afternoon, the air was still, and there wasn't a ripple on the water. The sun was a pale yellow haze through the low-lying mist. Trees only a couple of hundred metres away were turned into all kinds of mysterious shapes as the mist shrouded them, and those in the distance disappeared completely, leaving the layout of the landscape beyond to the imagination. And there I was with no paints, and not even a sketchbook! But there

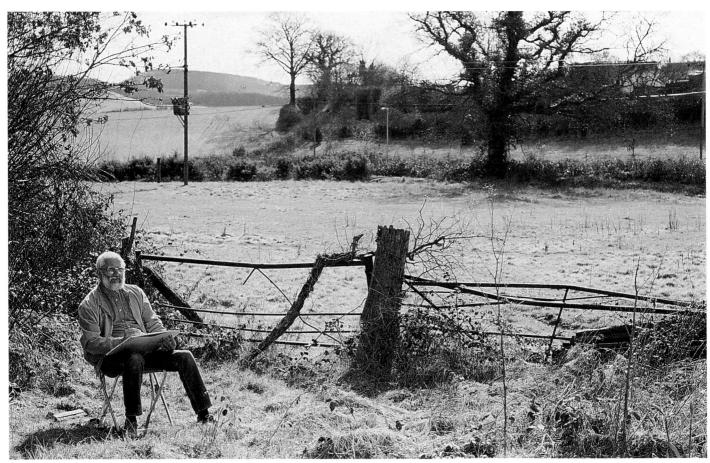

Fig. 4 Painting outdoors in Devon

are times, even for a professional artist, when it is right not to take your paints or sketchbook with you. Yet even in a situation like this you can take advantage of the chance to observe the scene, or whatever it is that has inspired you to paint, and commit as much information about it as you can to your memory. Then, at the earliest opportunity you have after the event, sketch what you saw from memory and have a go at painting it. Apart from the pleasure you will get from doing this, you will be learning one of the most important lessons in painting – how to observe.

My aim in writing this book is to teach you how to paint in watercolour out of doors, based on my own experiences. I find one of the most satisfying aspects of painting away from home is that you can enjoy a day out and at the same time bring back a permanent reminder of it in the form of a painting that you have created yourself. I have watercolour paintings in my studio which I will not part with (and I have to sell my paintings to earn a living!) because they hold memories of a day out and all the pleasures and mishaps that were experienced. Don't forget that painting can be an 'excuse' to get out of the house and enjoy nature. After all, with a sketch pad and paints you can wander almost anywhere in the search for an ideal subject.

In my opinion, there are two very distinct types of watercolour painting. The first is a very detailed style, in which all the paper is covered with paint and each area of the painting is patiently worked over several times until the required depth of tone and detail is achieved. Many Victorian watercolourists painted in this way. The other method is much less defined and allows the medium's characteristic qualities to determine the style of the picture. The result is a painting which appears simpler and not overstated. Fig. 5 illustrates a tree that I painted for an audience during a demonstration; it took about two minutes, using a No. 6 sable brush, and shows that many watercolour techniques need to be worked quickly for good results. This, of course, has two distinct advantages: first, it keeps the painting fresh and not overworked; and second, it makes good use of what is often limited time available for painting outdoors.

I hope that by the time you have 'practised' your way through this book you will be able to go outside and enjoy creating a painting that represents the scene you are looking at. I picked the word 'represents' very carefully because no two artists will paint the same scene in the same way. One picture may be very delicately painted with lots of detailed work, and the other may be done with only the minimum of brush strokes, almost drawn rather than painted. Fig. 3, for example, is a very simple painting, but it nevertheless succeeds in capturing life and atmosphere. It does not matter how simple your watercolours are; it is the way you represent the scene on paper, the way you

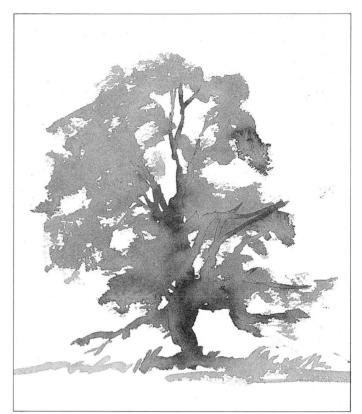

Fig. 5

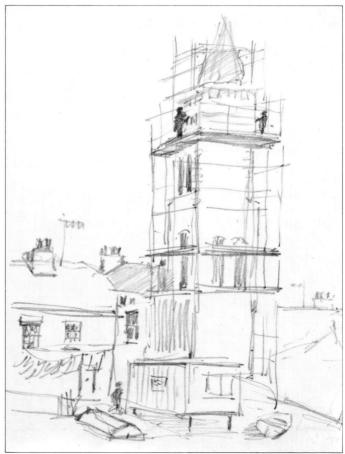

Fig. 6 The clock tower at Lympstone

Fig. 7 The Winkle Washers

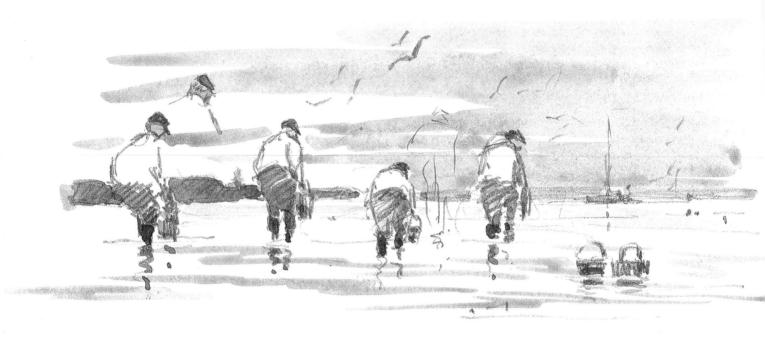

use your watercolour to achieve your desired representation of the subject that is important. In this way *your* personal style will begin to emerge, gradually developing as your experience of working with watercolour increases. When you work on the lessons in this book, at first your style will be similar to my own as you copy the exercises; but as soon as you feel you want to work in a slightly different way, follow your instincts: you will be developing your own distinctive style.

Do not be too concerned about making a distinction between sketches and paintings; treat any piece of work in watercolour, no matter how simple, as a painting. Sketches are done out of doors primarily as a means of collecting information for use on other paintings (usually larger) in the studio, but often a watercolour sketch can be a painting in its own right. In fact, some students produce their best watercolours in the form of sketches, for they are more relaxed when painting 'just a sketch' and therefore work their brush strokes very confidently. So you will see that another of the most important things to learn is to have confidence in your painting. I will help you gain this as we work through this book together.

One of the merits of watercolour painting out of doors is that you need very little equipment (see page 10) and it doesn't take long to get it together, pack it up, and go out to paint. Because of this, a one- or two-hour painting trip can be easily organized and will always be worthwhile – but a full day out painting has its own special excitement.

I experienced just such a day in March, when everything seemed to go right – the weather, the subjects, the sketches and the paintings. My wife June and I had decided to go to Lympstone, an old-world village situated on the Exe estuary and an artist's paradise. I have painted there before, but I always leave it wanting to return. The day dawned with everything shrouded in a typical March mist but, putting on my best 'weather forecasting' cap, I went outside and decided that it would clear and leave a nice day, so all my sketching gear was put into the back of the car and off we went. Sure enough, the mist started to lift and by the time we arrived at Lympstone the sun had broken through and we could see over the Exe estuary to the hills on the other side. The village is a lovely place, with old buildings, narrow streets, and small passages between the houses leading down to the water's edge. After parking the car, we went straight down to the quay and looked around to get our bearings; the view we had is illustrated in fig. 8. When I first saw it. however, the sun was behind the houses and they seemed rather 'flat', lacking contrast. I estimated that it would be another couple of hours before the sun moved round to the side, so I didn't paint this picture until later in the day. Always bear these kind of considerations in mind when looking at a possible scene to paint.

However, on the left of this view I saw the clock tower shown in fig. 6, looking much larger than usual as it was covered in scaffolding. So, there and then, I

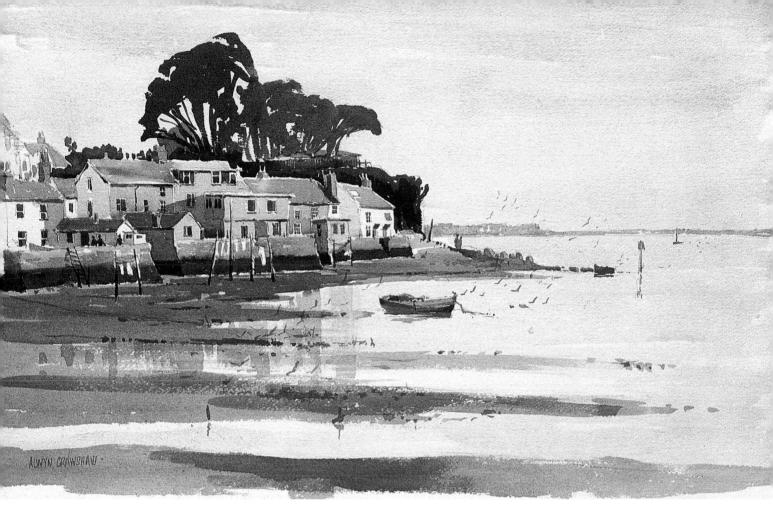

got my sketchbook out and started to sketch it; but while I was busy doing this June pointed out a fisherman in the shallow water of the harbour who seemed to be washing something in a basket. The sight instantly reminded me of one of those old nineteenthcentury paintings – there were no cars in sight, only seagulls, boats, the sun, the still estuary water and this lone fisherman doing what had probably been done for centuries in exactly the same way. I stopped working on the clock tower and on another page of my sketchbook (cartridge paper) did some quick sketches of him before he disappeared, using a 2B pencil. After all the panic to sketch him quickly, however, he was still there one and a half hours later, so I was able to paint over some of the sketches in watercolour (fig. 7). We later stopped to talk to him and discovered what he was doing. Another fisherman had joined him by then and they were washing winkles in wooden slatted baskets, by dipping them in the sea and shaking them vigorously. Apparently they keep fresh for a few days if washed like that. As we walked up from the harbour we passed an old estate car parked nearby, containing plastic sacks full of winkles ready to be washed: the twentieth century hadn't missed the winkles, although as artists we like to think that it just might. With all this diversion, I never got round to painting the clock tower, so it stayed as the pencil sketch vou can see here.

The beauty about little places like Lympstone is that each vantage point is very close to the next. Within

Fig. 8 Lympstone from the harbour wall

five minutes we climbed a short path up from the village and found ourselves in a field on top of a small cliff. The view was panoramic, overlooking the Exe estuary. We enjoyed every minute of it, but it was not a good view to sketch as it featured too much water, and the distant hills, fields and buildings were too far away for the pencil or brush to capture satisfactorily. Instead, we went back to the village to find some lunch, and then returned to the harbour to have another look at the view of the quay. This time the sun was in just the right position, stronger, and very warm for the time of year. The open water of the estuary was absolutely still, like a mill pond, and we could see right over towards Exeter, about six miles away. I worked the painting in fig. 8 on Whatman 200 lb Not, and used an HB pencil for the drawing. As I sat there, painting the houses on the waterfront, feeling the warmth of the sun, listening to the seagulls chattering and to the occasional voice of a fisherman, with the invigorating smell of the sea all around, I realized that it is the combination of such pleasures which makes painting out of doors so rewarding. I hope that you too will discover this as you take your watercolours and start painting outdoors. It is a marvellous feeling when you have a satisfying and successful day painting in the fresh air. They are not all like that, of course: I can remember a day on the Yorkshire moors . . . but that's another story!

WHAT EQUIPMENT DO YOU NEED?

All artists have their favourite brushes, colours and other materials, so in the end it is up to you to choose your equipment from your own personal experiences. But if you are a total beginner you will need guidance, so to begin with I suggest you use what I use. This will also make it easier for you to work through the exercises in this book, as I use the same materials for all my watercolour work. If you are a little shy of going into an art supply shop to buy materials, just take this book along for reference and you shouldn't have any problems. For the best results, remember that the golden rule for all painting is to buy the best equipment you can afford.

If you have painted before in watercolour, you will know what suits you best and this chapter will only be of general interest; but read it nevertheless, because you may find something you had not thought of or tried before and you could be inspired by your new 'find' to paint even better pictures.

Colours

There are two categories of watercolour paints. Artists' Quality Water Colours are the best quality, but Georgian Water Colours also provide the leisure painter and student with very high-quality paints at modest prices. Watercolour paints can be bought in a ready-fitted box or you can buy an empty box and fill it with the colours of your choice. There are three different sizes of paint pan (the receptacle in the paint box that holds the segment of paint): a whole pan, half pan and quarter pan. In fig. 9 my box contains twelve whole pans of paint and in fig. 11 the small box contains twelve quarter pans. This box measures only $5 \times 8 \times 2$ cm $(2\frac{1}{2} \times 3\frac{1}{4} \times \frac{7}{8}$ in), has its own water carrier, water container and small brush, and comes readyfitted with the selection of colours you can see in it. It is shown opened and closed in the photograph.

Colours can also be bought in tubes; these are squeezed on to your watercolour palette or the open lid of your paint box and then used in the same way as pans. Colours in tubes are ideal if you want to saturate a brush in strong colour, using less water, but I do not advise beginners to use tubes because it is difficult to control the amount of paint on the brush. I never use tubes, but if you feel like working on larger-size paper and you want to get a lot of paint on to it, then have a go with them and enjoy it. The colours I use throughout this book are shown in fig. 24 on page 22.

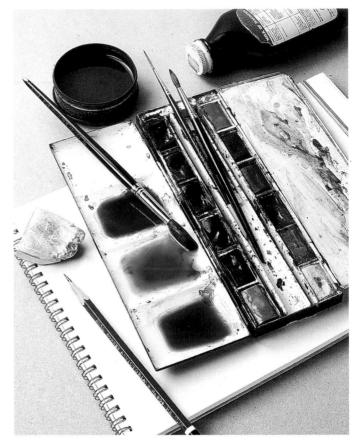

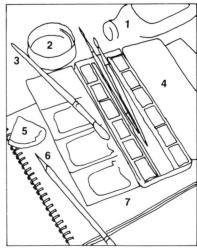

Fig. 9 Basic equipment

- KEY
- 1 water carrier (bottle)
- 2 water holder (tin)
- 3 brushes (Nos 10, 6 and 2)
- 4 paint box
- 5 kneadable putty rubber
- 6 HB pencil
- 7 watercolour pad

Brushes

Now for the most important piece of equipment you will ever buy - your brush. Brushes are the tools with which you express yourself on paper, and the way in which you use them will reveal your skill to those who look at your paintings. This applies to watercolour more than any other medium. A single brush stroke can express a field, a lake, the side of a boat, and so on: therefore, it is important to know your brushes and what to expect from them. The best-quality watercolour brushes are hand made from Kolinsky sable. They are the most expensive brushes on the market. but they give you perfect control over your brush strokes and, if properly cared for, will last a very long time. Pure red sable brushes are the next best quality: they give excellent results and are not quite so expensive. There are also many other real-hair brushes available, such as those made of squirrel hair, ox ear hair. and ringcat hair; these are cheaper than sable but softer, allowing less control. In addition, the development of good-quality synthetic brushes over the last ten years has been remarkable. The 'Dalon' series in particular are excellent and are to be found in almost every artist's equipment. The brushes I use are shown actual size on page 13.

Paper

What paper should you work on? One could almost write a book on this subject alone, but to simplify matters I have assembled several pieces of different paper (fig. 14) and indicated their names, grades, and weights. I have also shown you what effects a pencil

Series 63 Squirrel hair wash brush (large flat)
Series 270 Nylon brush No. 10
Series 56 Sable and ox hair brush No. 2

Fig. 10 A selection of watercolour brushes (actual size)

and a brush stroke of colour give you on each type of paper. The paper is reproduced actual size. When artists talk about grades of paper they simply mean the texture of the working surface. For instance, Rough means the surface is rough; Hot Pressed (HP) means the surface is very smooth; and Not (sometimes called Cold Pressed or CP) indicates that the surface is in between rough and smooth – by far the most commonly used surface. The weight of the paper is determined either by grams weight per square metre (increasingly the most common method) or by calculating how much a ream of paper (500 sheets) weighs. So, if a ream weighs 300 lb (which is about the heaviest paper you can use), the paper is so called (with its manufacturer's name and surface type) – for example, Saunders 300 lb Not. You will find a good weight of paper to work on is 140 lb (285 to 300 gsm). The secret of finding the right (not necessarily the best) paper to work on is to try out different ones until you discover a paper that suits you. Then use it, practise on it and get to know it. When you know how your paper will react when you paint on it, you will be well on the way to mastering watercolour painting.

Basic kit

The list of tools and materials you could acquire is almost endless – there always seems to be something else you can buy – so at this stage, to stop confusion and indecision creeping in, I will go through the list of basic materials you need to start your watercolour painting out of doors. By 'basic' I am not referring to their quality but to the minimum quantity necessary to begin with. You will soon discover the amount of

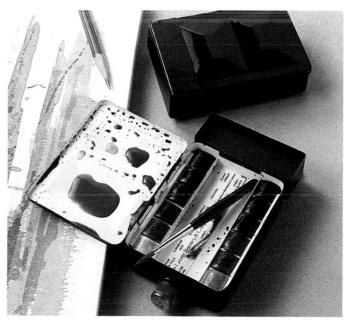

 $\begin{tabular}{ll} Fig.~11 & Small~water colour~box~incorporating~water~carrier,\\ container~and~brush \end{tabular}$

Fig. 12 My painting waistcoat

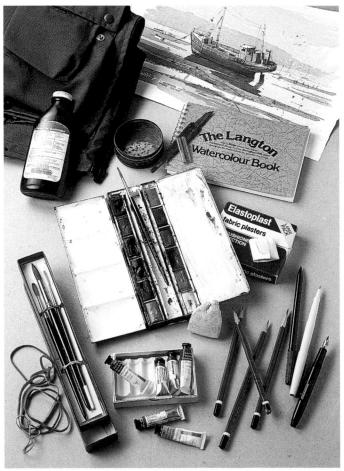

Fig. 13 The equipment my waistcoat carries

materials you require as you gain experience, and you can build up this basic kit to suit your own needs. Some artists, for example, will use only one piece of paper per trip, while others will use a dozen. I always take spares or extra materials with me when painting outdoors, simply because I cannot afford to run out of something miles away from home.

First you need a paint box – if you look at fig. 9 you will see mine, which holds twelve whole pans of colour. Three brushes should be sufficient – a No. 10 and No. 6 round sable, and a Dalon Series D.99 No. 2 (the very thin one). Usually round brushes are graded from size No. 00 to No. 12, and some manufacturers make a No. 14 size. This scale can be seen in fig. 10 and the brushes are reproduced actual size. A round brush is a general-purpose brush. Also illustrated are three other brushes suitable for watercolour painting. You will also need an HB pencil, a 2B pencil for sketching, a putty rubber, a water carrier, something to hold your water in while painting (in fig. 1 I am using an old tin), and of course paper on a drawing board or a watercolour pad. I don't use an easel for work up to 38×51 cm $(15 \times 20$ in) as it is easy enough to work with the board on my knees. I usually take a folding chair along with me although in most cases it is not too difficult to find somewhere to sit if you haven't got one. Depending on your sketch pad size – they start at 13×18 cm $(5 \times 7$ in) – you might be able to put the whole lot in your pocket or handbag. Keep your materials simple to begin with.

I always wear the 'sporting' waistcoat shown in fig. 12, which is showerproof and has many large pockets, when going out painting, which means I no longer have to worry about keeping all my equipment together and in an easily portable form. It takes all I need as a professional (including spares) and I wear it as a jacket – easy for climbing over fences, up rocks, etc. At a moment's notice I can put it on, pick up a chair and a pad and I'm ready to go off painting, knowing that I've got all I need, although I usually check the waistcoat first to make sure. Fig. 13 shows the waistcoat with its pockets emptied and all the materials and equipment which go in them. These include a paint box, brushes, pencils and pens, a rubber, a knife for sharpening pencils, extra paints, a water carrier (plastic bottle), a water holder (old tobacco tin), a small sketchbook, spare rubber bands to hold sketchbook pages down, and a box of sticking plasters and aspirin - you never know what's going to happen and you can be a long way from civilization.

Finally, remember that ultimately the choice of materials to use is very personal. For guidance initially, use the materials I have suggested, but as you gain experience, feel free to experiment with others to suit your own requirements.

Fig. 14 A selection of suitable papers for watercolour painting	
Whatman 200 lb Not	инв НВ
Whatman 200 lb Rough	HB
Greens Pasteless Board 300 lb HP	2B
Greens RWS 140 lb Not	HB HB
Saunders 140 lb Not	НВ
6 ROWNEY S. A	2B
Cartridge paper	2B
Greens De Wint 90 lb Rugged	28
Greens Camber Sand 90 lb Not	2B
Layout paper	2B

WHAT CAN YOUR BRUSH DO?

Well, here we go! Please note that in all instructive illustrations I have used solid black arrows to show the direction of the brush stroke and outline arrows to show the direction in which the brush is travelling over the paper.

At first, use any paper you want for these exercises – even brown wrapping paper. The object here is to get the feel of your brush and to learn how to make it do what you want.

There must be thousands of different brush strokes you can make, but after thirty-five years of painting and many hours of working for you on these exercises, I have come up with fourteen, divided between my No. 10 and No. 6 brushes. Remember, all these brush strokes can be made larger or smaller than I have made them (here they are all reproduced actual size), each mark can be created differently by adding more water to your brush, and different paper can also produce different results. Naturally, you can use any size brush for any brush stroke. Start to experiment; use any brush, any paper, and find out what your brush can do. Don't throw your results away; keep them to refer to and use them to remind you of what you can achieve. When you have practised the strokes illustrated here, start to create some different ones of your own.

Fig. 15 Using your No. 10 sable brush

- **a** This is the natural line your brush will make when painting horizontally using medium pressure.
- **b** The brush is held differently here. I use this stroke when I want to keep a definite edge at the top. The underside is uneven.
- **c** Here the brush is held and used in exactly the same way as in **b**. At the end of the horizontal stroke the brush will be flat; by keeping it flat but turning the brush on its edge, you can use it to paint downwards. This gives a neat edge to the end of the area being painted.
- **d** This shows how flexible your brush can be. Vary the pressure of the stroke as you paint a continuous line.
- **e** This is the dry brush technique. Use only just enough paint in your brush, so that it will start to run out during the brush stroke, creating the characteristic hit-and-miss effect. It will take a lot of practice to be able to judge how much paint to use, so keep at it.
- f A good brush can cope with this kind of work without any problem. The brush is pushed hard on the paper then pushed upwards, letting the brush hairs splay out in all directions. You will automatically get dry brush effects when doing this. I use this technique for foreground grass, hedges, etc.
- g This illustrates how to fill in a small area, when three sides are to be kept within a given shape, i.e. chimney stacks.

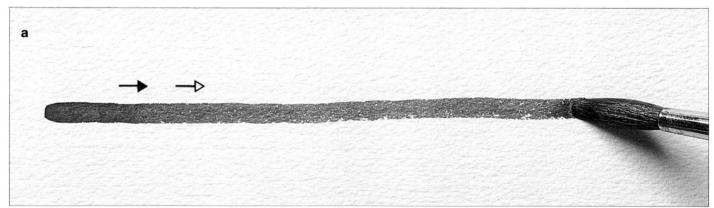

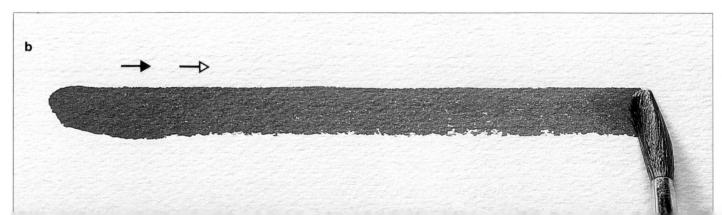

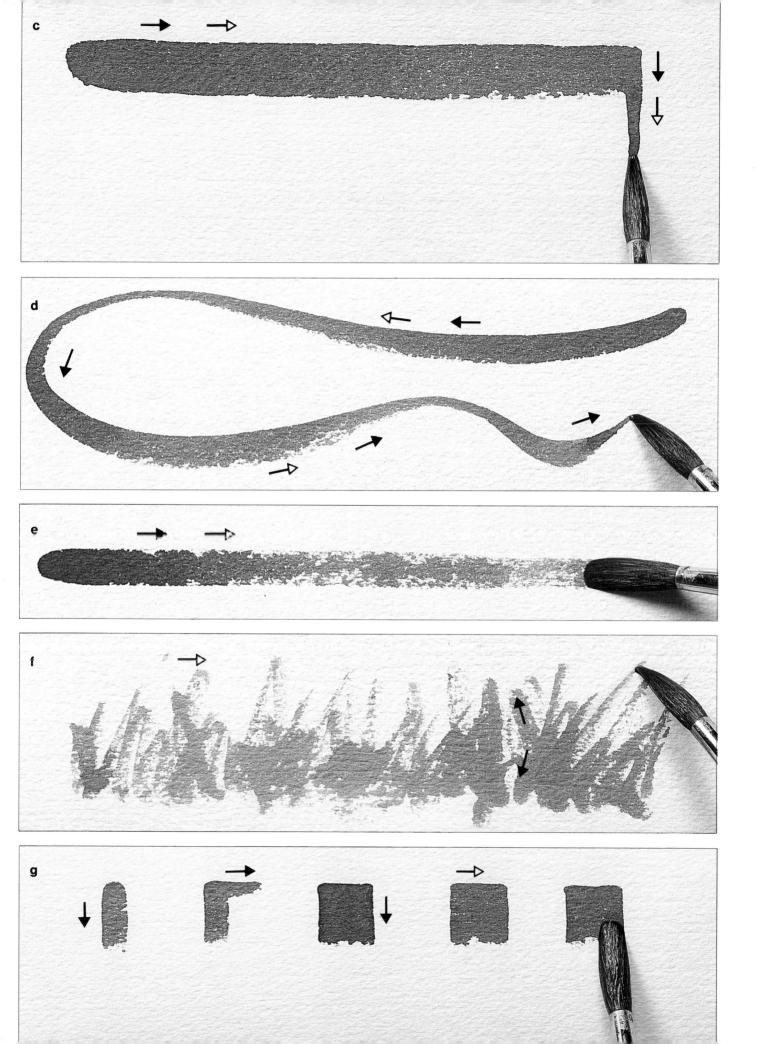

Do not worry if you find some of these brush strokes difficult at first; practise them, and they will soon develop. Finally, if you cannot master them all, improvise with some of your own strokes and no doubt you will paint just as well. Good luck.

Fig. 16 Using your No. 6 sable brush

- **h** This is the same stroke as **a** except that it is painted with a No. 6 brush. They are both general-purpose strokes and are therefore very important. Use this brush to practise **b** as well. Also, it is important to learn how to vary the pressure of your brush while it is moving across the paper. Try this stroke again, but this time start with more pressure and as the stroke progresses, gradually lift the brush off the paper.
- i This takes the last stroke a step further. Load the brush and paint a continuous line while at the same time varying the pressure of the brush. Remember to have enough paint on your brush to take you through the whole stroke.
- j Here are a few more general-purpose strokes. The verticals play an important part in paintings, so they must become second nature to you. Note: if you are drawing a line with your brush

up to about 5 cm (2 in) long, vertical or horizontal, you will move only your fingers; but for longer lines you must move your whole arm, otherwise the line will start to curve.

- ${\bf k}$ These strokes will help you use your brush effectively for small work. When you have done this exercise (moving only your fingers), repeat all the strokes but make them longer (this time moving your arm).
- I This is similar to f, except that the brush is moved from right to left and left to right. Push down on the ferrule end of the hairs and let them splay out as you move the brush backwards and forwards. You will get a natural dry brush effect.
- **m** This funny-looking doodle is perhaps one of the most important strokes of all. It shows you how to fill irregular areas and move on to other areas, filling them all with colour. When you have mastered this technique, you will feel very much at home with your brush. You must mix enough paint and the secret is to keep it watery.
- **n** This last stroke is really an extension of **m**. First paint four distinctly separate strokes to give you a rectangle. Work fairly quickly as these strokes must remain very wet as you fill in the area with paint, or you will end up with a darker line around the edge of the rectangle.

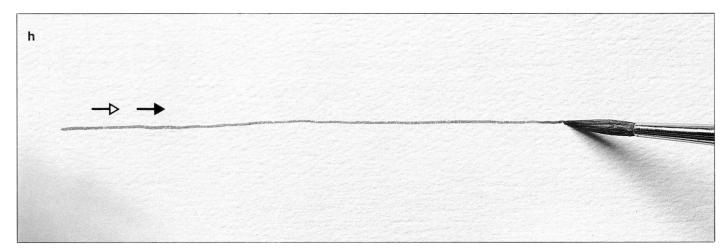

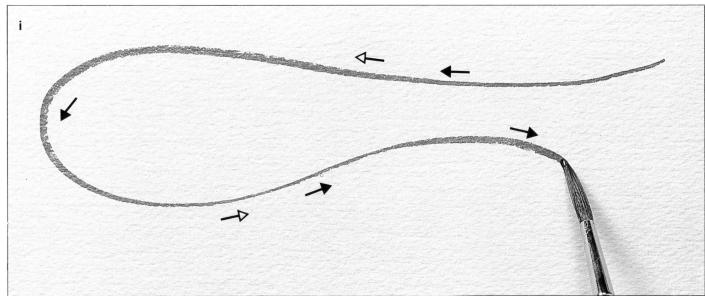

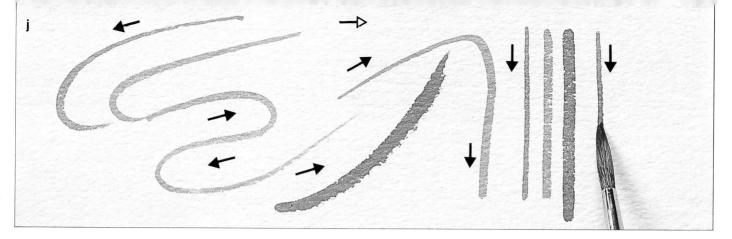

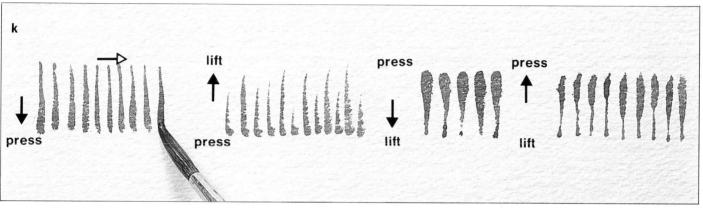

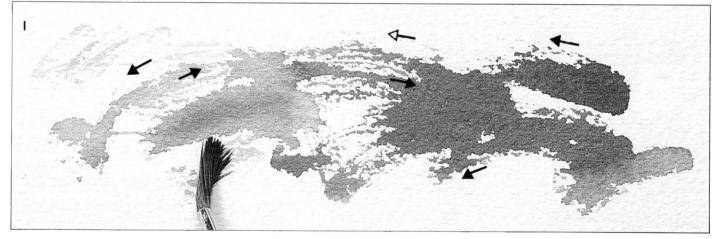

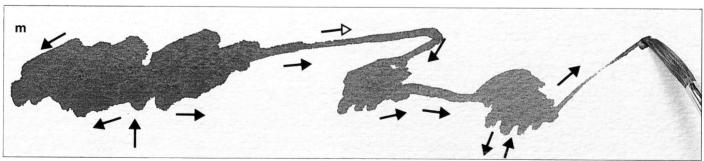

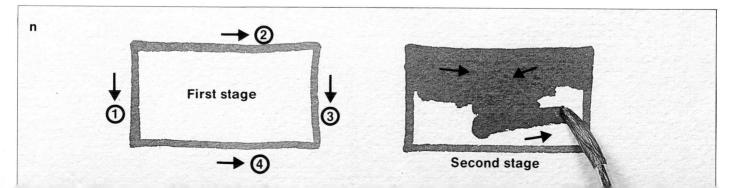

DRAWING EXERCISES WITH A BRUSH

It is impossible to show every brush stroke used in these exercises, so I have indicated just the important ones. Do not worry too much about drawing them exactly like mine, or you will be too restricted in your brush strokes. Draw them with an HB pencil first.

I have called these 'drawing' exercises because 90 per cent of a painting consists of drawing with a brush. If you haven't used colours before, read page 22 first and practise mixing colours before you start. All these drawing exercises were worked twice as big as shown here and I used only the three primary colours (red, yellow and blue). If you like, use only one colour. Figs. 17 and 18 were painted on Whatman 200 lb Not and fig. 19 was done on Bockingford Watercolour Paper 200 lb. I used my No. 6 sable brush for all the work except for the barbed wire and television aerials,

which were painted with my Dalon Series D.99 No. 2 brush. You can use either your No. 6 or your No. 10 sable brush for any of the brush strokes from **a** to **n**.

In fig. 17, when you use k2 for the trunk and branches of the tree, make long as well as short strokes and paint over with I while the branches are still wet. The church speaks for itself. Paint the water first, let this dry, then paint the reflection with m. When you paint the birds, use a combination of all the strokes in k and at different angles. Birds look easy when painted well, but they need a lot of practice. The street light and the fence are straightforward. For the large post, start your brush stroke at the top and work downwards, using e. If you find the telephone box too complicated at this stage, work on some other exercises first and come back to it later.

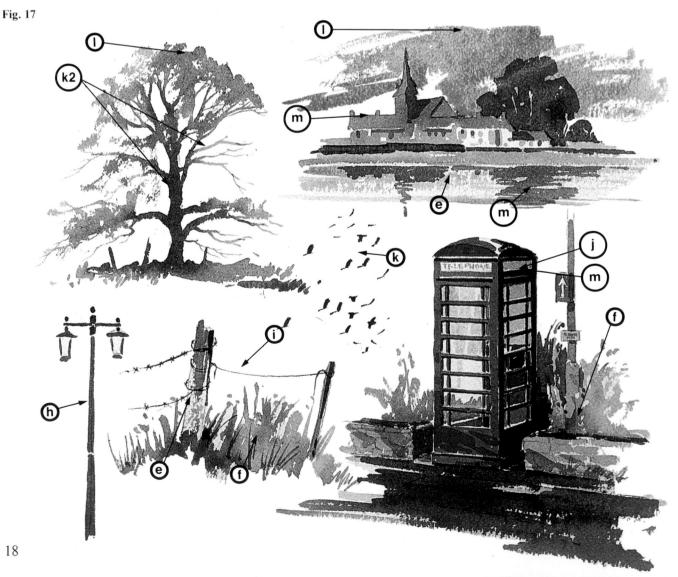

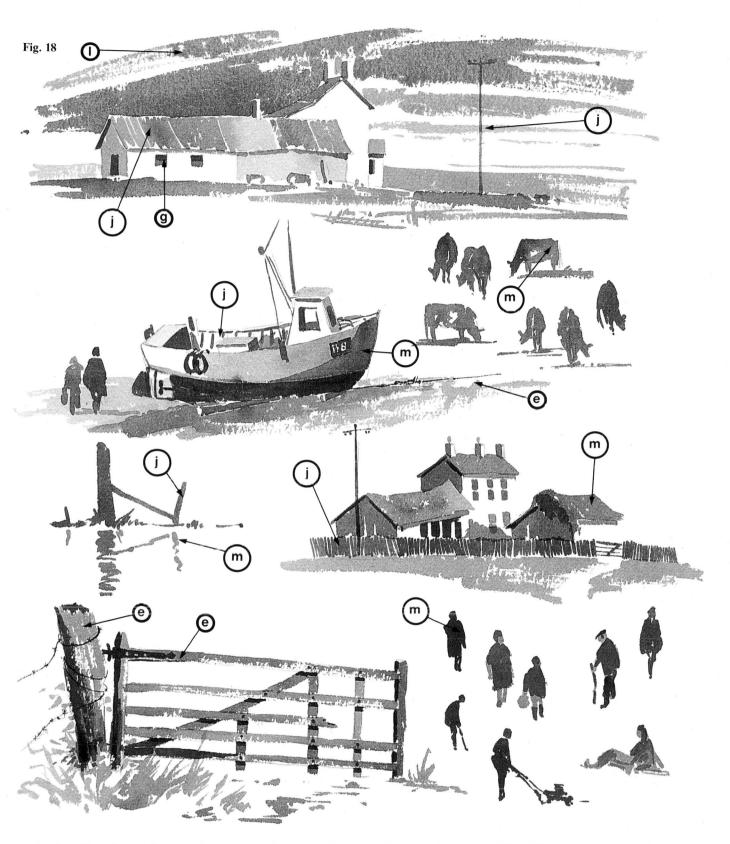

In fig. 18, where j is used (at an angle) on the farm roof, notice how I let some brush strokes touch and merge together, as I did on the fence in the lower group of buildings. This stops them looking too regular. The cows and people are drawn almost as they would be with a pencil, worked from top to

bottom (see page 23). When painting the boat, make sure that each area of paint is dry before applying another wash. The drawing of the post shows how simple it is to suggest water, just by painting a reflection on white paper. When you work on the gate, wait for the paint to dry before adding the shadows.

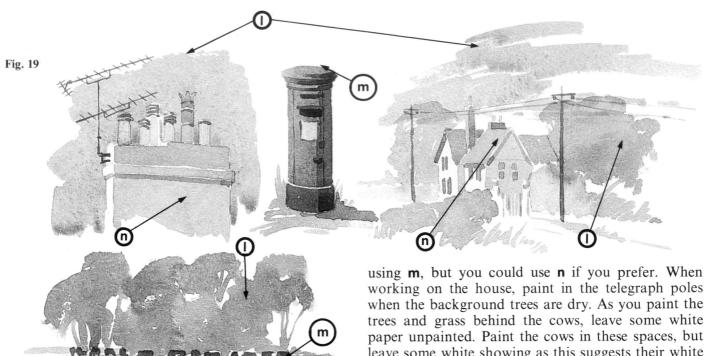

In fig. 19, paint the sky around the chimney first and then, when it is dry, paint the chimney stack, pots, and television aerial. Incidentally, I never object to television aerials - in fact, I think they can even add character to a building. The postbox was worked

working on the house, paint in the telegraph poles when the background trees are dry. As you paint the trees and grass behind the cows, leave some white paper unpainted. Paint the cows in these spaces, but leave some white showing as this suggests their white markings and gives an impression of movement.

The painting below (fig. 20) was worked on Whatman 200 lb Rough and measures 51×76 cm $(20 \times$ 30 in). I have included this picture here to show you that a large painting is worked in exactly the same way as the smaller exercises you have just done. The details illustrated opposite (figs. 21-23) are reproduced actual size to enable you to study the brush strokes more clearly.

Fig. 20 (below) River Otter, Devon

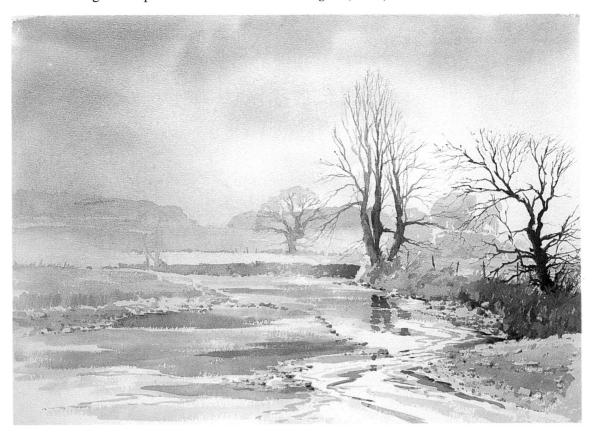

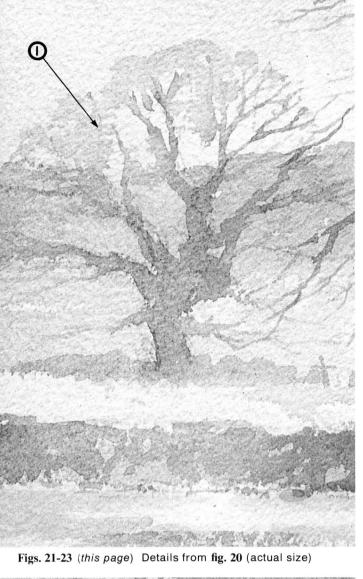

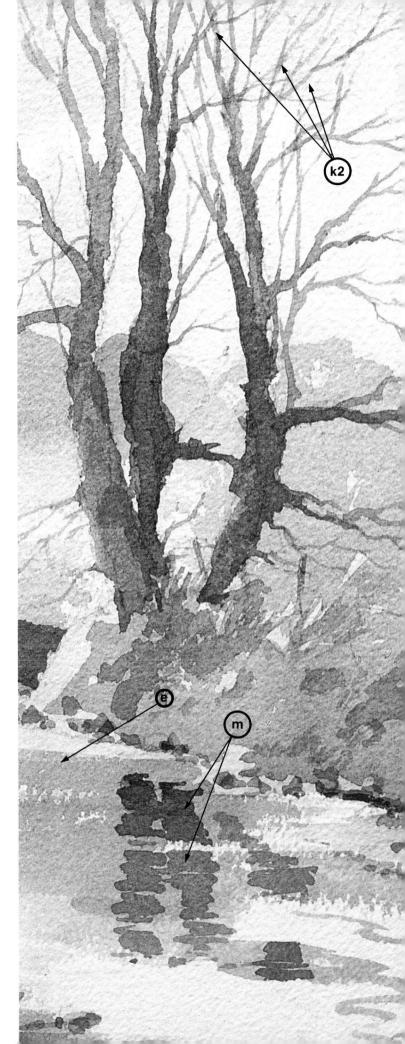

EXERCISES USING THREE COLOURS

For anyone who has never painted before the thought of mixing colours to match those of nature must seem terrifying; after all, there are thousands of them. Well, it is much easier than you think, because in fact there are only three basic colours, the primary colours, to work from – red, yellow and blue. All the other colours you see around you can be mixed from these three. There are of course different reds, yellows and blues to choose from, to help with your colour mixing: fig. 24 shows two of each colour that I use. Naturally, there are also ready-mixed greens, oranges, purples and so on that you can use, but to start with we will use just the three primaries.

When mixing colours for the paintings in this book it is very important to note the first colour that I specify (printed on the exercises or mentioned in the text) as this is usually the main colour of the mix, with other colours added in smaller amounts. For instance, if you wanted a yellowy orange, you would put yellow on to your palette and add red to it; if this were done in reverse, the red could overpower the yellow and you would obtain a reddy orange. Fig. 24 also shows you the colours I have in my paint box and some other colours I have mixed to help you to start. Always look around you and try to mix the colours that you see – you cannot practise enough. If you find it difficult at first, don't give up; you'll get there in the end.

The paintings on the opposite page were worked with a No. 6 sable brush on Whatman 200 lb Not. In all the exercises, except for those starting on page 48, the stages are simulated. In other words, I have painted a picture with, say, four stages, four times – once for each stage. The exercises starting on page 48 were photographed as each stage was completed, and therefore you are seeing the same painting progressing from start to finish.

In the previous section you painted a tree, but here (fig. 25) I have shown it being worked in several stages. When you paint a tree this way, the colour must remain wet from the beginning to the end of the painting. The sequence of the first silhouette figure (6 stages) is done with one continuous brush stroke and takes, from head to toe, only about two or three seconds to complete. The pink one is painted similarly, then 'clothed' when dry. The crowd scene shows how people can be worked out of a dark background. The tree in full leaf is worked in exactly the same way as the first one, but with the addition of more wet colour to the leaf areas. In the last exercise, note how

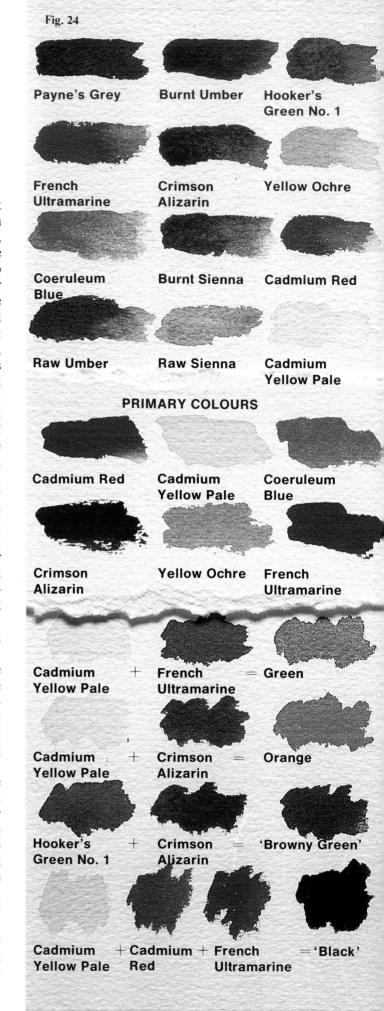

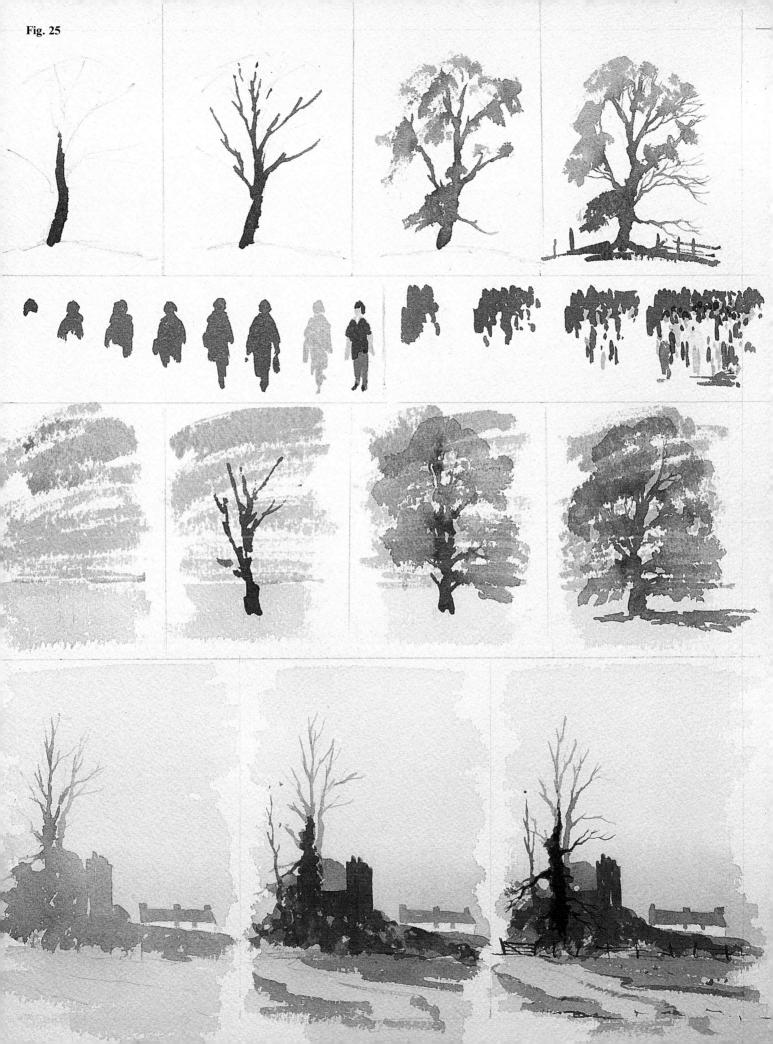

the cottage is left as unpainted white paper and the dead elm tree is painted over twice to darken it and bring it into the foreground. Remember, when you paint on a wet colour you will get a soft edge; if you want to achieve a crisp edge you must paint on a dry surface.

The following three exercises were painted one and a half times the size reproduced here. For the steamroller (fig. 26) I worked on Bockingford Watercolour Paper 200 lb. You will find that this is more absorbent than Whatman paper and therefore gives you a softerlooking, less crisp picture. This paper seems to encourage the colours to blend together when they are wet in a very distinctive way. You can also easily take most colours off it with a wet brush, which can be very helpful. I find this paper better for working a painting quickly, and subjects can be suggested with less overpainting than on some other watercolour papers. Most of my watercolour work is done on Whatman paper, but naturally there are times when I use different papers in order to achieve different results. But let's get back to the steam-roller

After painting the sky and letting it dry, I then put just one wash of green over the bodywork, and one of grey over the wheels, using a No. 6 sable brush. I left white paper where I later added Cadmium Yellow Pale for the brass decoration. When all this was dry, I painted over the shadow areas of the bodywork with a darker green wash and the wheels with a darker grey wash, and painted in the ground. Then I painted in the two men and the ground shadows. The roof support rods were painted with a Dalon Series D.99 No. 2 brush. Finally, using my No. 6 brush again, I worked in the smoke, using watery paint to help it blend in with the sky.

For the boat exercise (fig. 27) I used cartridge drawing paper (the most common paper for sketchbooks). Once again, this paper is quite different from those already mentioned; it doesn't absorb the paint quickly so the paint seems to run over the surface. We used to use it most of the time at art school as we couldn't afford watercolour paper for general practising. I used my No. 6 sable brush for this painting except for the rigging where I used my Dalon Series D.99 No. 2. Take great care when painting the water that your brush strokes are horizontal, or the water will look as though it's running downhill!

Now back to Whatman paper for the cottage nestling in the hills (fig. 28). Again I used my No. 6 sable brush for this painting. Note how the trees are worked very simply, making a dark background which contrasts well with the sunlit side of the cottage. Remember that in watercolour painting, you rarely have to paint all over the paper; here the rocks and foreground are mostly areas of paper that have been left unpainted.

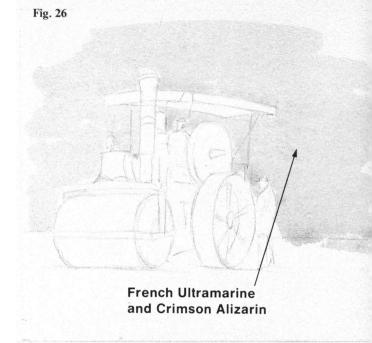

Cadmium Yellow Pale

and French Ultramarine

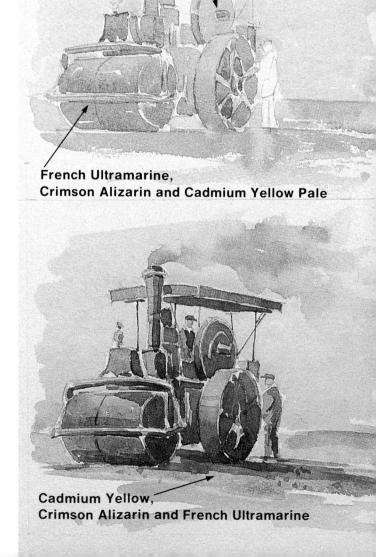

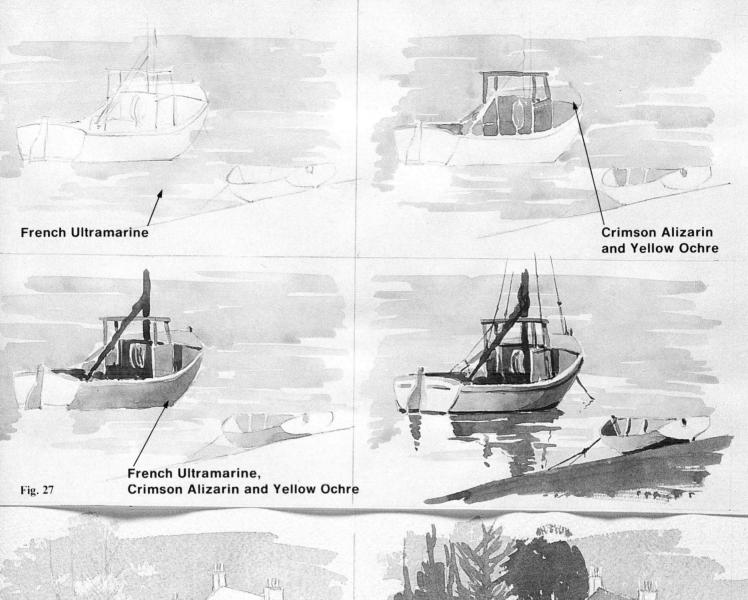

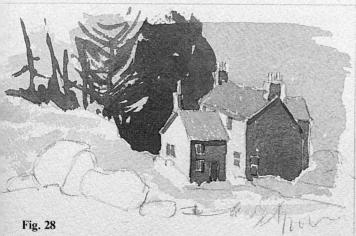

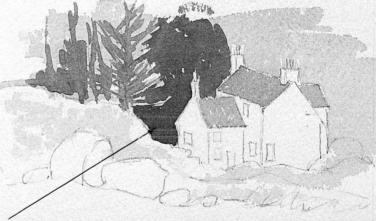

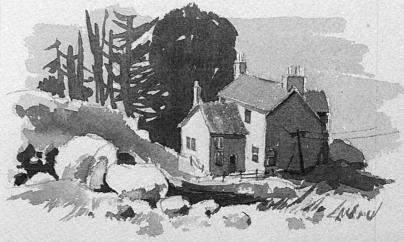

HALF-HOUR EXERCISES

USING SIX COLOURS

I cannot overstress the importance of half-hour studies, for they give the beginner and less experienced student confidence in the medium. This happens in three ways. First, they prevent the more experienced painter from getting too 'tight' with his painting and will encourage him to work more freely. Second, they teach you to observe, which is one of the most important aspects of all painting, and particularly when working outdoors because once you have left the scene of your painting you may never have the chance to return to it for a second look. So, by working to get everything done in half an hour your skills of observation will become very acute. You will learn to look at the size and colour of objects in your scene and relate them to one another. What colour is the nearest field compared to the middle-distance fields? How tall is a person in relation to the big tree on the left? – and so on. The third merit of half-hour exercises, if you are a beginner, is that the discipline of completing a painting in half an hour will give you confidence in handling watercolour. It doesn't matter how bad you think the result is - you must paint what you see in that time. Naturally, paint is going to run together when you do not want it to, and lines that are meant to be straight will become wobbly. But don't worry; the most important fact is that you will get used to watercolour and will not be afraid to let your loaded brush work on the paper.

Work small at first, approximately 18×28 cm $(7 \times 11$ in). Before you start painting, look at your scene and study it (take as long as you like); half close your eyes to establish the light and dark areas of shape and tone. Then draw in with a pencil the main features. When you have done this, observe your subject again very carefully, decide how you intend to tackle it, gather all your concentration, and begin. The half hour starts now, not at the drawing stage. Before you go out, copy any of the exercises in the book, if you want, for practice. The larger the picture you paint in half an hour the more free it will be. Try one small, then repeat it larger each time.

My half-hour exercises were painted on Whatman 200 lb Not, the size as above, and they haven't been touched since I got off my stool. The details (figs. 29 and 30) are reproduced actual size. Notice how, because of the speed of working, I have left white spaces (paper) where I painted one wash against a wet one (to prevent them running together) in the farm painting.

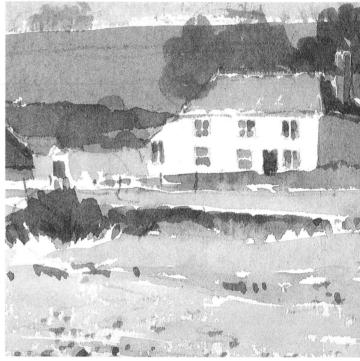

Fig. 29 Detail from fig. 31 (actual size)

Fig. 30 Detail from fig. 32 (actual size)

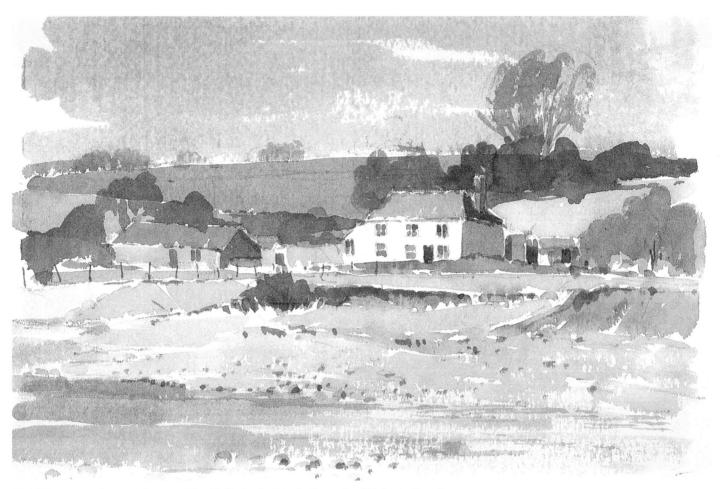

Fig. 31 (above) Country Farm Fig. 32 (below) Bluebells under Clinton's Beech

WORKING OVER PENCIL ON CARTRIDGE PAPER

Cartridge paper, as I said earlier, is a good surface to practise on, but it is particularly invaluable for working outdoors. If you haven't got time to work on a full-blooded watercolour, you can draw the scene in your sketchbook (cartridge paper) and add the tones by shading in with your pencil (2B). You can then paint over this sketch with watercolour, using quite simple washes, as the pencil tones will show through the colours, giving depth to the painting. I often use this method on holiday (see page 44).

The end result of the first exercise (fig. 34) looks quite complicated, but it is the pencil work that gives this illusion, not the colouring. Including the drying time, the painting only took about ten minutes. It is only 15 cm (6 in) wide and the washes of colour were done very freely and simply, using a No. 6 sable brush.

The same applies to the church in the next exercise (fig. 35). I used a wash of green, mixed from Cadmium Yellow Pale, French Ultramarine and Crimson Alizarin, allowing it to vary slightly in colour as it was applied. The church tower was painted in with Cadmium Yellow Pale and a little Crimson Alizarin. In the final stage, a darker wash was put over to give contrast, including a shadow on the church tower.

I painted *Ripley Church* (fig. 33), 41×43 cm (16×17) in), in just the same way as the exercises except, of course, that I did this outside on the spot. It took me about an hour and a quarter to draw and paint the picture, but if I had done this on watercolour paper as a pure watercolour, it would probably have taken me about three hours, and would have looked more 'finished', less free in style.

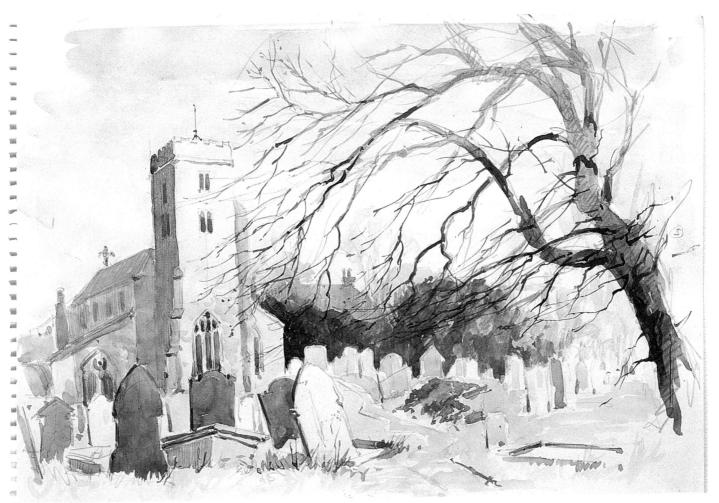

Fig. 33 Ripley Church, North Yorkshire

Fig. 34

French Ultramarine and Crimson Alizarin

Fig. 35

Cadmium Yellow Pale, French Ultramarine and Crimson Alizarin

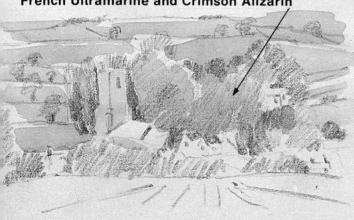

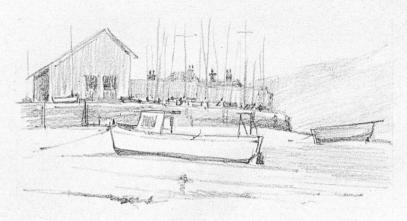

Yellow Ochre, Crimson Alizarin and French Ultramarine

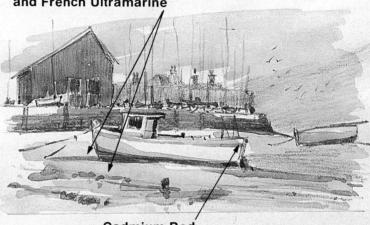

Cadmium Red

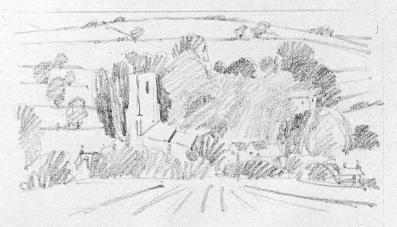

Cadmium Yellow Pale and Crimson Alizarin

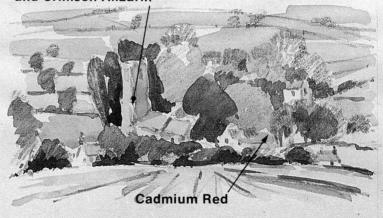

SIMPLIFYING NATURE

The object of these next exercises is to show you how to simplify scenes to be painted. I have done this by illustrating a photograph I have taken of a painting spot and then showing you how I translated nature into paint. This is *not* an exercise in copying from photographs, although, of course, I had to use the photographs to work from, for reproduction purposes. It is intended as a guide to help you understand the problems of painting from life and not be mystified by them.

The chapters 'Finding a Painting Spot and When to Finish a Picture' and 'Composing a Picture' will help you to find a scene to paint. When you have found it, take your time and observe what is in front of you, and then decide how you are going to paint it. This is the most important stage of your painting and it doesn't matter how long it takes you. Never go headlong into your watercolour without preplanning it in your mind. The sheer excitement of painting out of doors can take control at the start of a painting session – and this is a good thing, because it means the inspiration is there - but do not let it get in the way of thinking and planning first. All these exercises were painted 11×8 cm $(4\frac{1}{2} \times 7$ in), using a No. 6 sable brush. They cover a tremendous amount of ground so study them carefully and then copy them for painting practice. Don't just look at the finished painting; compare it with the real-life scene (the photograph).

Skies Skies are very important to a landscape as they show us what type of day it is – sunny, rainy, cold, etc. When you paint a sky, however, don't try to copy every cloud and shape you see. The sky is constantly changing and it is impossible to copy it exactly; by the time you have mixed your colour the sky will have moved on and changed. Therefore, look at it carefully and watch the overall movement and pattern. Then, using what you can see as a guide, paint an impression of it. Look how simply fig. 37 is painted and yet it conveys perfectly the idea of moving clouds on a blustery day. Figs. 36 and 37 were both painted on Whatman 200 lb Not.

Trees The autumn wood (fig. 38) was painted on Greens RWS 140 lb Rough. The use of the dry brush technique on the rough surface helped to achieve the effect of the sun shimmering through the leaves. You

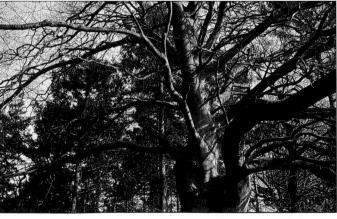

From the top: Figs. 36, 37, 38 and 39

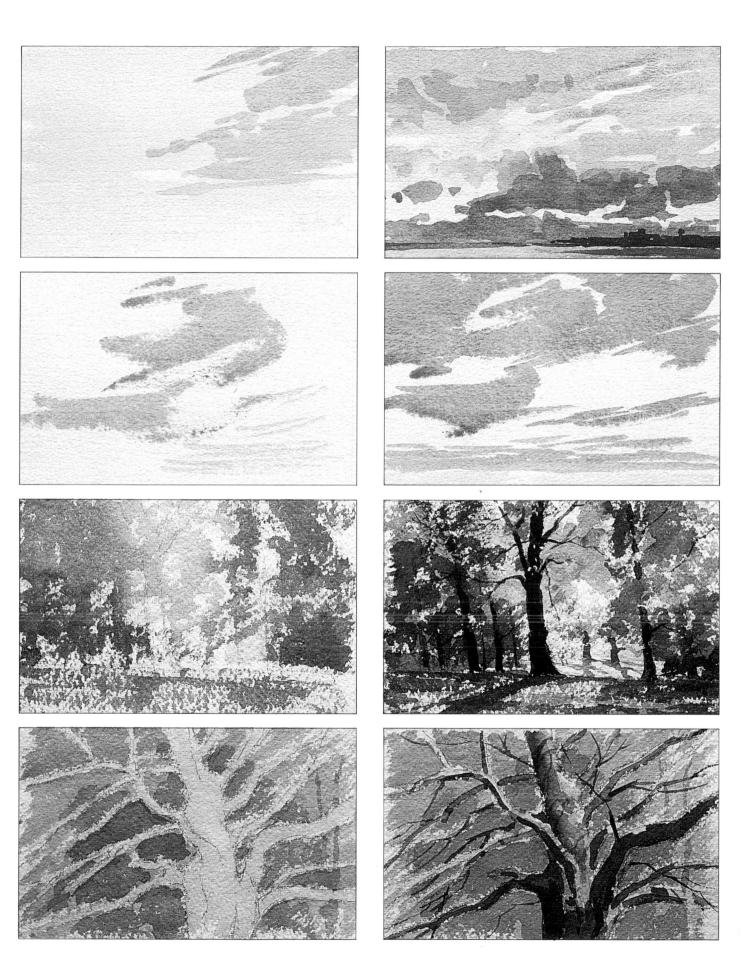

will see that I left out the large branch on the right-hand side of the tree in the foreground, because I felt this helped the composition. The beech tree in fig. 39 was simplified by omitting the mass of trees in the background and putting in a simple darker wash over the French Ultramarine sky. Don't try to copy every branch you see on a tree; include just the main ones to give you its overall shape and character, and then improvise as you wish. Fig. 39 was also painted on Greens RWS 140 lb Rough.

Buildings You must accept the fact that to paint buildings successfully you need to be able to draw reasonably well. This doesn't mean that you have to be capable of drawing detail, but you must be able to draw the overall image that you see. Look at figs. 40 and 41 and you will see there is no drawn detail at all. When you look at a scene, you must be aware of the darks that are formed by shadows and the light areas formed by the sun, because it is the shapes made by these dark and light areas that create the form of your subject. Look at your scene with half-closed eyes and you will see a pattern of shapes emerge. The first stages of the exercises here were achieved with only one wash of paint; in the second stages a further wash was painted on for the shadow areas. I left unpainted paper for the white of the buildings. I used Whatman 200 lb Not for both these exercises.

People They always seem to be a problem in a painting – they never stay still long enough for you to complete your work! You must accept that you will probably have to finish the figures in your composition by relying on your imagination and experience. So, until you have practised enough to become reasonably proficient, keep clear of prominent figures in your paintings. Practise painting them as I showed you on page 23 at first. You can put this type of figure into your work in the middle distance (like those in fig. 41). Then practise making them bigger; the larger they are, the more definition you will have to add, but whatever you do, don't put too much detail in them keep them free and simple and they will look correct in a watercolour painting. Note that I have suggested only the features of the man on the beach and the man in the striped jersey in fig. 43: the rest have only got pink faces, applied with a simple brush stroke in each case. Fig. 42 was done on Whatman 200 lb Not and fig. 43 on Daler Watercolour Board Not.

From the top: Figs. 40, 41, 42 and 43

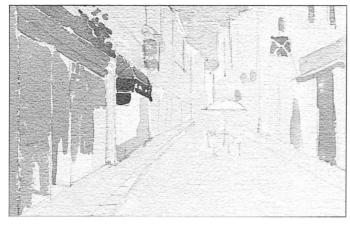

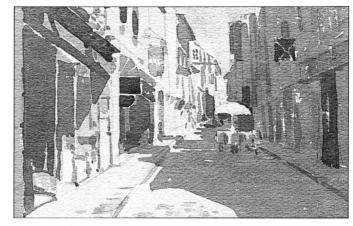

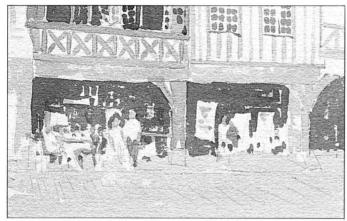

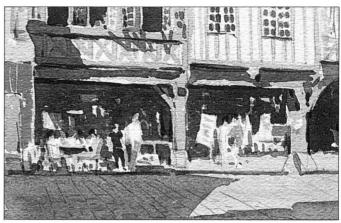

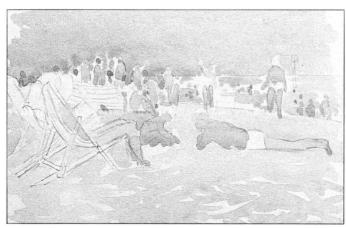

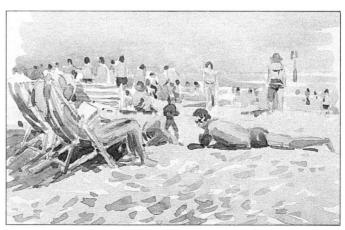

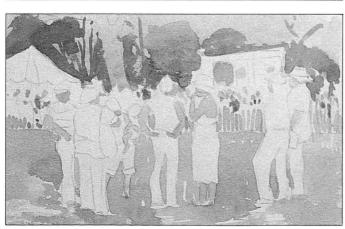

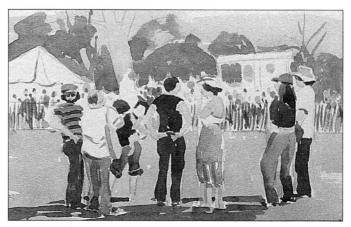

Water Paintings of scenes featuring water, if it is painted well, seem to hold a fascination that other pictures lack. This might be because people assume that water is very difficult to paint. I don't think it is any more difficult than nature's other subjects, but it must be looked at with a specific view to painting. First observe the overall image and then the patterns that are formed on the water by the reflections of the surroundings. As always, half close your eyes to help you see definite shapes. If the water is moving, don't let your eyes follow the movement; keep looking at one spot to pick out the reflected shapes.

Fig. 44 was painted on Whatman 200 lb Not. I painted in a wash of French Ultramarine for the water. leaving white paper for the reflections to create movement. When that was dry, I applied a second darker wash, adding Crimson Alizarin and a little Yellow Ochre to the original wash. Finally, I darkened the left side of the white boat reflection by adding a very pale mix of French Ultramarine and Crimson Alizarin. In fig. 45, also done on Whatman 200 lb Not, the water is applied so simply and yet so effectively by means of the dry brush technique. This is one of the best and surest ways of creating the illusion of water. By dragging a dry brush across the river, areas of white paper are left which give an impression of sunlight on rippling water. When this wash was dry, I painted the reflection in the same way. Incidentally, whenever I refer to a painting being very simple, I mean the effect is simple; it doesn't necessarily mean that you will find the application easy at first. But as you gain confidence in yourself and your work it will become so.

Animals There is the same problem with animals as with the sky and people - they will not stay still! Whenever I paint horses, I usually start with one, get halfway through, then it moves on and I either have to wait until it comes back in roughly the same position, or improvise the finish. Unless the animal is held for you, or is in a 'staying' position like the horses in fig. 46, you will become proficient at the subject only by sketching and getting to know animals through constant work and observation. Just as you practised painting people in the middle distance by using a single brush stroke, I suggest you try this with animals. Obviously it is a help to be able to paint quickly for this type of subject. Again, always remember to look for the characteristic shapes and colours, and go for simple forms to begin with. The sheep in fig. 47 were painted in this way. The grass was painted freely around them, leaving white spaces for the animals. A couple of simple washes were then added to give character to the sheep. Figs. 46 and 47 were both painted on Whatman 200 lb Not.

51111

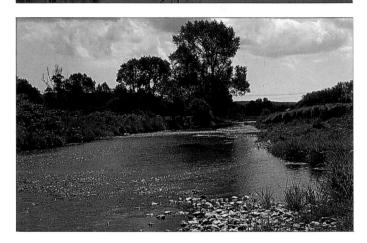

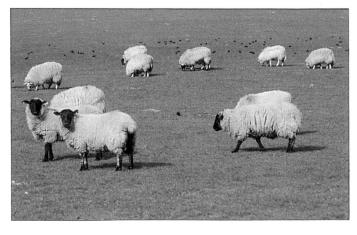

From the top: Figs. 44, 45, 46 and 47

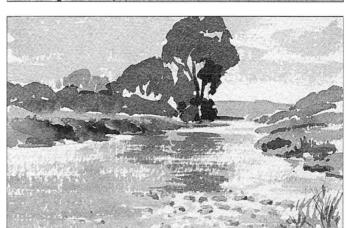

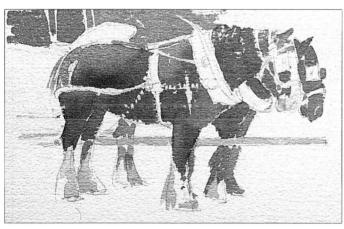

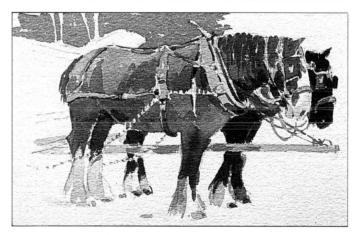

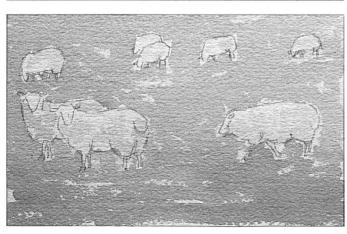

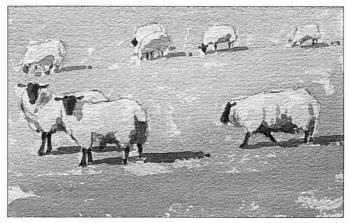

Distance You must never paint anything in the distance too prominently. Do not overwork it or try to put too much detail into it; the more detail you include, the more it will seem to come forward into the foreground. The further away the object, the cooler the colours, and the nearer to the eye, the warmer they become. Therefore, when painting distant objects (hills, fields, buildings, etc.), use a touch of blue with your colours to cool them down and keep them in their place. With a picture like fig. 48, don't try to draw all the trees and fields you can see with your pencil – do this with your brush as you work. This will stop you trying to follow existing lines too rigidly. Unless a fairly detailed pencil drawing is necessary as a guide for very accurate painting, your pencil work should be kept simple in watercolour paintings or they will always lack that certain natural freedom of expression that is characteristic of watercolour.

In fig. 49 note the lack of detail in the work. Look carefully at the brush strokes and you will see they are little more than simple blobs and dashes of paint, yet they give the impression of activity in the distance very well. I have not tried to paint every house and every boat as definite objects. As always when you do a subject like this, look at it through half-closed eyes before you start. Both figs. 48 and 49 were done on Bockingford Watercolour Paper 200 lb.

Close-ups Most students get very concerned about the foreground in a picture because as it is closest to the onlooker it is assumed that it must be full of detail. True, the painting must convey the relative closeness of the foreground, but the detail can be suggested and does not necessarily require a great deal of intricate drawing. In fig. 50, worked on Whatman 200 lb Rough, I drew the shape of the old metal objects and worked the background freely around them. Then I painted them in with a little more accuracy. In fig. 51 there appear to be lots of carefully drawn (detailed) pebbles and rocks on the foreshore, but in fact they were not drawn and painted in detail at all. I worked on Whatman 200 lb Rough again, and the first wash, using the dry brush technique, left my pebbles on the beach automatically - all 'happy accidents'. I purposely left some areas of white paper for the larger rocks. When the first wash was dry, I went over it with another wash of darker colour in the same way. Finally, I painted some shadows for the stones. The important point to grasp here is that I didn't actually draw the small pebbles: they emerged from the foreground which my brush created by means of the dry brush technique and by adding some dark, shadow areas to indicate form. The lesson to learn here is to let the medium itself help you in your painting.

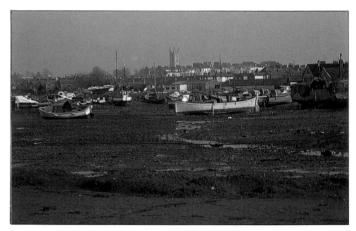

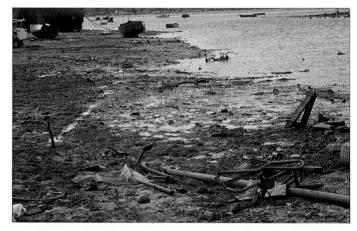

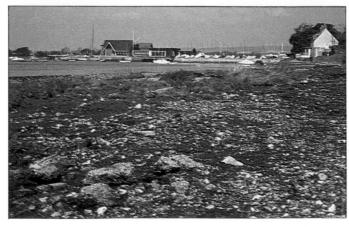

From the top: Figs. 48, 49, 50 and 51

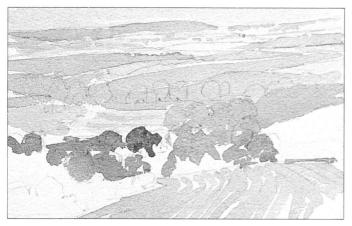

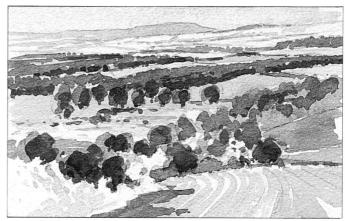

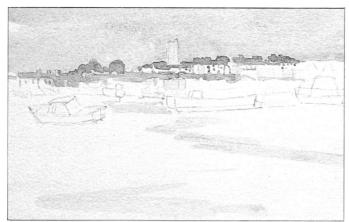

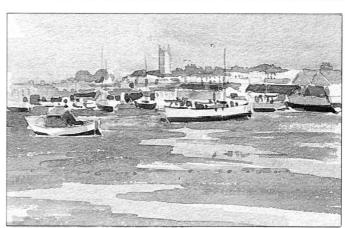

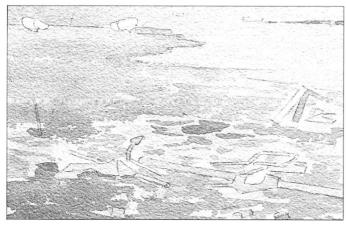

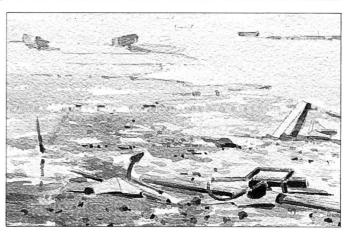

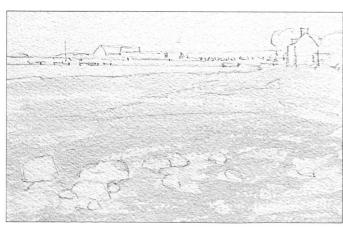

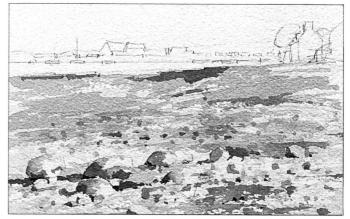

USING PEN AND WASH

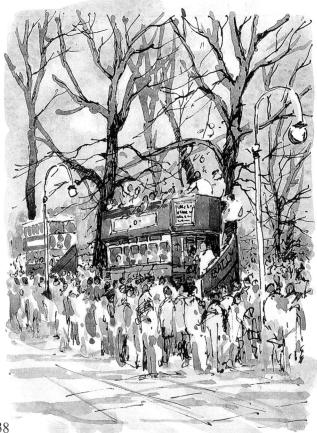

The combination of pen and wash is not just an extension of watercolour, but a medium in its own right. The pen can be used in two ways: you can draw your picture, using Indian waterproof ink, and then lay on washes of colour over the pen work; or you can paint your picture first and then draw over the colours with a pen to give definition and character. In these three exercises I have used the latter method – I prefer it, as I am not restricted to working within the pen lines with my colours – but as always the other option is also open to you.

The first exercise, fig. 52, is one of those moving subjects again - the trouble is, they're everywhere when you get outside! This kind of subject is really for more experienced students. If you find painting moving subjects too difficult, there are plenty of stationary ones as well so try one of those instead. The way to cope with a scene like this - an Easter Parade with buses of all ages passing by – is first and foremost to find a spot where no one can block your view - not easy, but it can be done. Start to draw in pencil the scene in front of you, leaving a blank area where you think the buses (or whatever) will pass. The crowds will remain constant, although people will be coming and going all the time, so don't try to change your drawing every few minutes. Prepare some basic colour washes and keep your paints ready. When the buses arrive you will have from two to four minutes to draw them. Fortunately, with a free style like this you need not be concerned too much about detail, so when you have finished your drawing, paint in as fast as you can with your prepared washes. You can work more loosely than I have, and don't worry about wet colours running into each other - the pen will 'clean' everything up for you. One last tip, when you paint your own procession bus from life: find out where the bus park is situated, and when you have painted all you can, find your bus in the park and finish any detail work you need. Alternatively, before the procession, go and sketch the bus you want in your picture in some detail and use the sketch for reference when the bus has moved on in the procession. For this exercise I worked on Greens Pasteless Board 300 lb Hot Pressed and used a dip-in pen.

The Welsh river scene in **fig. 53** is much simpler – it allows the artist time to look and think. Notice how freely the colour is applied before adding the ink in the second stage. I worked this on Ivorex board. The third exercise, fig. 54, is a very simple snow scene. Look how the pen and ink (used very sparingly) helps to make the scene sparkle. This was done on Daler Line and Wash board and, like the other two exercises in this section, was worked one and a half times the size reproduced here.

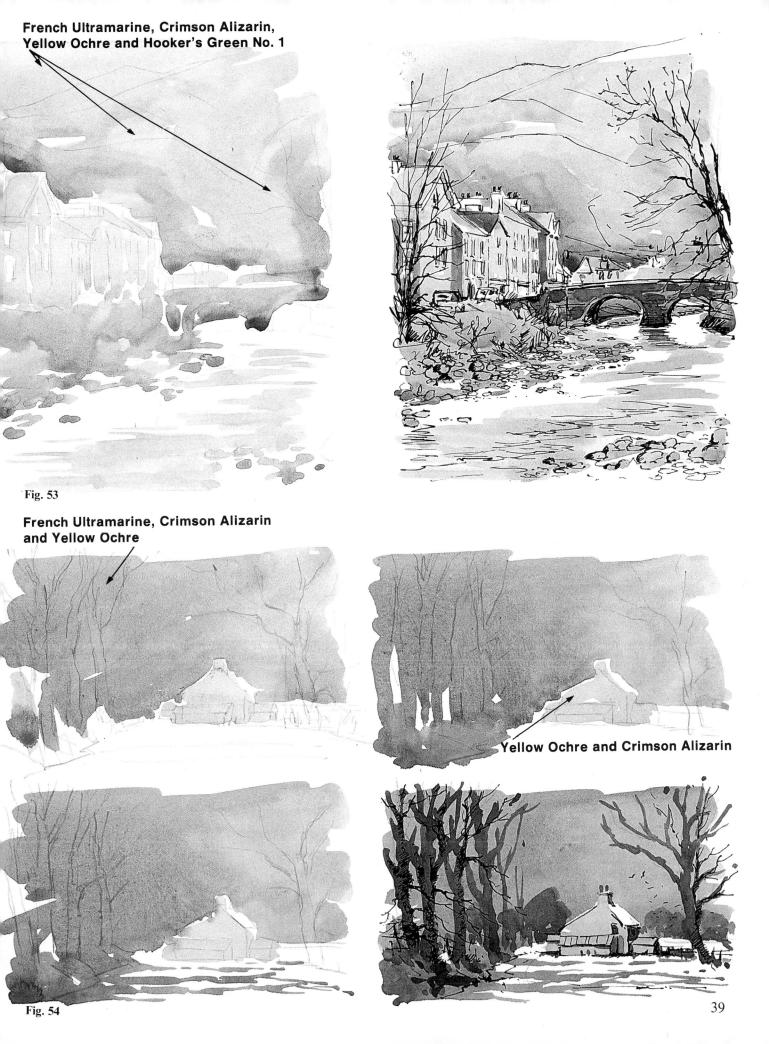

FINDING A PAINTING SPOT AND WHEN TO FINISH A PICTURE

Finding a suitable painting spot is obviously very important. Let me introduce you to my four 'M's – minimum equipment, maximum comfort, minimum searching, and maximum observation.

Minimum equipment I have said earlier that it is better to keep your materials to a minimum for easy carrying; it goes without saying that to walk half a mile to a painting spot, only to arrive leg-weary and tired because of all the equipment you have carried, doesn't start the painting day off in a happy, relaxed mood.

Maximum comfort By not having too much equipment to carry, naturally you will be able to walk to your spot in reasonable comfort. But it doesn't finish there. Have you noticed how a musician takes great trouble to arrange himself and his instrument on the stage, making sure he is in a correct and comfortable position to perform? Similarly, a professional footballer will only kick the ball when his body is in the right, balanced position. Well, the same rules apply equally to painters. I have seen students holding down an easel against the wind with their legs, while one hand is trying to stop the page they are working on from blowing over, with their mouth full of brushes, a roll of kitchen paper held down firmly to the ground with their left foot, their paint box precariously balanced on their knees and, to top it all, sitting on a folding chair which is wobbling to the point of collapse because of the uneven ground. Such artists all seem to have the same style of painting – very free and out of control! Remember that when you are out painting, you are performing your art, just like the musician, and you must make yourself as comfortable as possible; painting creates enough problems, so eliminate as many as you can. Remember, too, to wear suitable clothing when painting outdoors; you must be warm or cool enough (depending on the season) to do your best work.

Minimum searching I am afraid that I have to keep reminding myself of this 'M'. For me the hardest part of all when going out painting is to find a spot to paint. This doesn't mean I cannot find places; the trouble is, I find too many and still look for more. When I take a class of students out, I usually suggest that we all stay close to our painting spot so that I can communicate with them, but there are always a couple who manage to find themselves in the next field, and the next, and the next The secret is to paint the first scene that inspires you and not be tempted to go into the next field or round the next bend of the river to find another spot that might be even better. It probably won't be, and it's easy to waste your painting time this way. Remember that the distance you walk away from 'base' has to be walked back!

Fig. 55 Summer

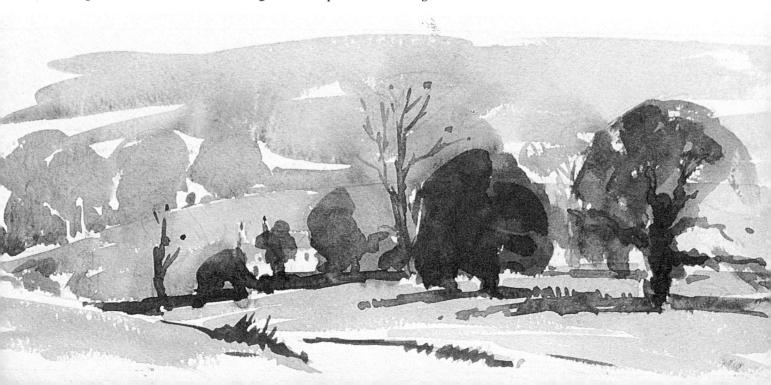

Maximum observation The last 'M' is one of the most important skills you have to learn when painting. No matter how proficient you are with your brush strokes and colour mixing, to paint a picture outside you have to be able to observe and understand the scene in front of you and put it down on your pad. Whenever you are out walking, or a passenger in a car, or sitting in a train, look at objects around you as if you were going to paint them. Compare the size of a distant farmhouse with a tree that is nearer to you – is it smaller, larger, more brightly coloured, etc? What happens to clouds when they reach the horizon? How does the colour of a cloudless sky high above you differ from the colour of the sky at the horizon? How many windows has that building got compared to the one next to it, and are the roofs on the same level? How high does a street lamp come up the building - the first-floor window or the second-floor one? I could go on indefinitely Basically, you should look for shapes and their relationship to each other in terms of position and colour.

When is a watercolour finished?

A painting is finished when the artist feels that he has sufficiently captured the scene in front of him. The degree of finish can vary considerably as the paintings here illustrate.

Fig. 55 was done on Bockingford Watercolour Paper 200 lb and measures 13×30 cm $(5\frac{1}{4} \times 12$ in). This simple painting could be called a sketch or, just as easily, a finished watercolour. **Fig. 56**, *The Distant Church*, which measures 28×41 cm $(11 \times 16$ in), is a pencil drawing done on cartridge paper with just a few delicate washes of colour applied on top. There were two reasons I decided it was finished at this

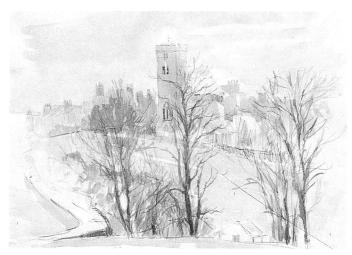

Fig. 56 The Distant Church

stage: first, I felt the effect of watery winter sunlight playing on the surface of the buildings had been achieved; and second, my hands were frozen! But of course if I hadn't already been satisfied with the painting at that point, I would have stopped, gone for a walk to warm up and then carried on. In contrast, look at the picture on page 46 of Whitby harbour: that has well over four hours' work in it, while The Distant Church took only half an hour. To me, however, they both tell the story and are both finished. Fig. 57, on Whatman 200 lb Not, was painted for a demonstration, freely and quickly, but I haven't touched it since then because I do not feel it needs more work. On page 5 you will see a very simple painting of our geese and ducks. I did this in about twenty minutes and the geese are little more than impressions; but again they tell the story to me and so are finished.

Fig. 57 The Wave

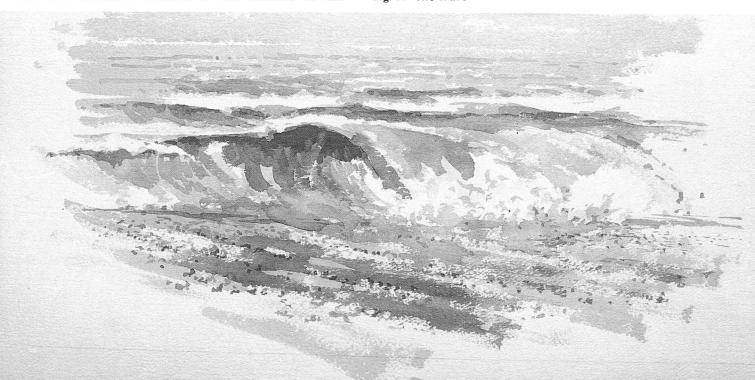

COMPOSING A PICTURE

Every artist uses and applies paint in a different way when he creates a painting. Similarly, the way each artist visualizes a picture (when looking at a scene from nature) varies from one painter to another. The composition of a picture is very personal – it will depend on how *you* observe your subject.

However, there are a few rules that should be followed. Fig. 58 shows the best way of determining where to put the centre of interest. Where the lines cross at **a**, **b**, **c** and **d** are the focal points, and by positioning your centre of interest on or around one of these, you should create a good design (fig. 59).

If you want your centre of interest to catch the eye, it must stand out against its immediate surroundings, either by means of colour (different or brighter) or a strong contrast between light and dark.

When painting a landscape or seascape, always place the horizon above or below the centre of the paper – never in the middle. Whenever you design your picture, leave an imaginary border around the paper and work within this. The border will give you extra space if you find you need it to extend your drawing and it will also be helpful when you mount your watercolour.

Now let us move out of doors and see how these rules are applied to nature. The biggest problem for all students is choosing the right subject. I find that the simplest way to pick out one picture from nature's thousands is to cut out a frame of thin card about 15×10 cm $(6 \times 4$ in). Hold up this masking card at arm's length and with one eye closed look through the 'window' at the scene in front of you. Move the mask around slowly, up and down and backwards and forwards, until you see a picture that fires your imagination (fig. 60). Make mental notes of the position your arm is in and where the keypoints of the scene hit the inside edge of the mask. Mark these on your paper and then you are ready to start.

One other great aid to designing is nature herself. The natural lines of a landscape – hedgerows, rivers, roads and so on – if observed carefully will also help to bring a picture together and automatically form a good design.

I took a photograph of a harbour scene (figs. 62 and 63) to help show you what you must consider when working outside. Look first at fig. 61: this was taken after I had moved a few yards to my right, but despite the sun, from the position shown here the composition is bad. Notice how the light (white) areas all merge

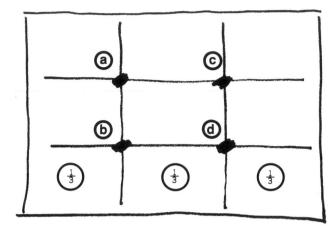

Fig. 58

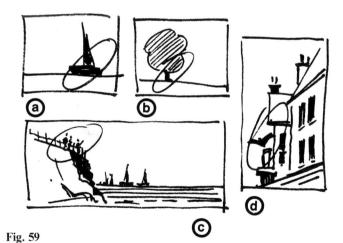

Fig. 60

together, so that adequate definition of the boats and boathouse roof is lost. The wooden poles also complicate the scene. This is an example of a poor place to stop and paint. Now look again at figs. 62 and 63: even without the sunlight there are at least three or four good pictures to paint in this scene, indicated by the different rectangles. Remember that here you see only what the camera saw; I in fact could see at least the same distance again on either side of the photograph. In this instance my camera lens acted as a mask, enabling me to find these pictures.

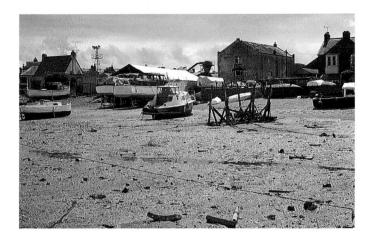

Fig. 61

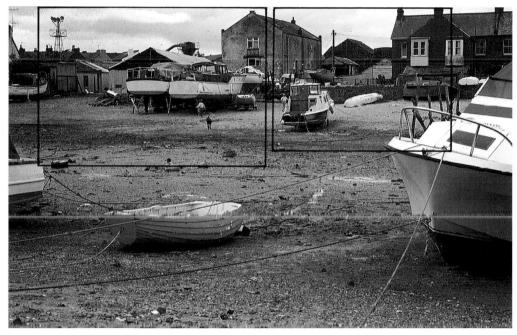

Fig. 62

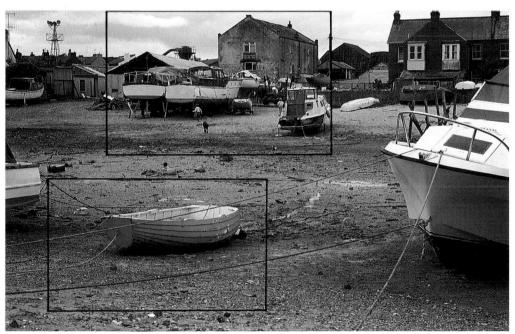

Fig. 63

RECORDING YOUR HOLIDAY

Fig. 64 Goathland, pencil sketch

There are two ways of painting on holiday. The first is to join an organized painting holiday, usually at a painting centre or hotel, where a tutor will look after you and teach you during your stay. I run some painting courses like these during the year, at a local country hotel. The advantages of such courses are that you receive some tuition and, most importantly, you can paint in the company of other enthusiastic students, which can be great fun. Information about this kind of holiday can be found in the monthly painting magazines.

The second type of holiday is the one I want to write about here, to guide and help you with. This is the annual holiday that most families take. On this sort of holiday, painting is not the number one priority because there is the rest of the family to consider, although, of course, if your partner paints it will be easier to arrange 'painting time'. Many of you who have been painting for some time will probably have been on holidays like this before, but for those of you who have yet to take your paints on holiday I will endeavour to describe here some of the important do's and don'ts for a family holiday with painting in mind, based on a holiday I had recently with my own family. Remember that many of the points I mention will also relate to painting out of doors in general.

We decided to go to Yorkshire for a week in the spring and as usual I packed my watercolour and sketching equipment; the latter comprised simply a sketchbook (cartridge paper) and pencils (2B). If you are travelling by car, as we were, you can take plenty of equipment, within reason. I always take too much, but better that than too little. Don't rely on stocking up with your favourite materials when you get to your holiday destination: you may find that the local art shop does not stock *your* particular brand of paper, paints and so on, and this could spell disaster for your holiday. You might also find that two or three days of your holiday go by before you can find or get to a shop. So remember to check your materials carefully before you pack them and don't leave any at home!

We had agreed before we left that I would paint at least three or four 'full-blooded' watercolours. It's a good idea to decide this kind of thing in advance, because it means that it has been agreed by the family that two or three mornings, afternoons or evenings will be for painting. Whatever you do, however, unless you can guarantee the weather, don't decide precisely which days you will work – you could find you have chosen all the rainy days!

Choosing when to paint is the biggest problem. I always took my equipment in the car, but left the

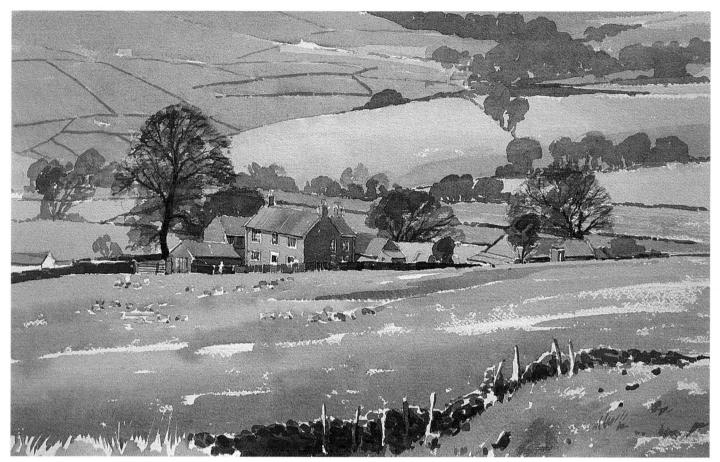

Fig. 65 Sheep on the Yorkshire Moors

decision as to whether to use it until we arrived at our preplanned destination. If the circumstances were right for painting, I had everything I needed. If not, I would carry just my sketchbook, 21×29 cm $(8\frac{1}{4} \times 11\frac{1}{2})$ in), with me for impromptu work—for when you walk into a painting scene by accident, not design. My watercolours would be in the waistcoat that I always wear (see page 12).

On our first day in Yorkshire we decided to drive around the coastal areas and do some sightseeing, but no painting. The weather during the week was always changing; we had everything from warm, bright sunlight to very heavy threatening storm clouds, mists and snow – ideal weather for an artist because the landscape was always changing too. It was sunny when we arrived at Scarborough, and in the harbour area the sun was dancing on the boats and water – I was inspired. Fortunately, we were ready for a rest so I took the opportunity to draw and paint the top left sketch in fig. 67, which took a little over half an hour.

We then drove to Whitby and parked the car by the docks. While travelling we had been watching a tremendous bank of very dark and ominous cloud that seemed to fill half the sky: it stopped over the car park! We decided to sit out the gloom, which gave me my second chance of a sketch (fig. 67, bottom right). The

view was fabulous, with the contrast between the dark sky and the sun catching the water and lighting up the large ship and houses. It still hadn't rained by the time I had finished, so we decided to drive up to an old monastery ruin and church on the cliffs. We were in part of the ruins when at last the skies opened and hail stones as big as mothballs, blown almost horizontal by a howling wind that seemed to have sprung up from nowhere, came hurtling down on us. On the way back down, I stopped in the graveyard on the edge of the cliff and was fascinated by all the red roof tops and the harbour below. I was determined to paint it; I would be back.

The first full watercolour I did, on Whatman 200 lb Not, was of a farm on the North Yorkshire moors (fig. 65). It was bitterly cold, but I was wearing plenty of clothing and I sat on my folding seat, using the car as a wind break – it didn't help much, but the coffee from the thermos flask did and I managed to work for about two hours.

On the day we decided to go to Whitby again the weather was sunny and dry, but cold in the strong wind. We went back to the cliff and I settled myself near the edge, which gave me the best view of the roof tops. Because of the strong wind blowing, it was a little hazardous and my materials were blown about

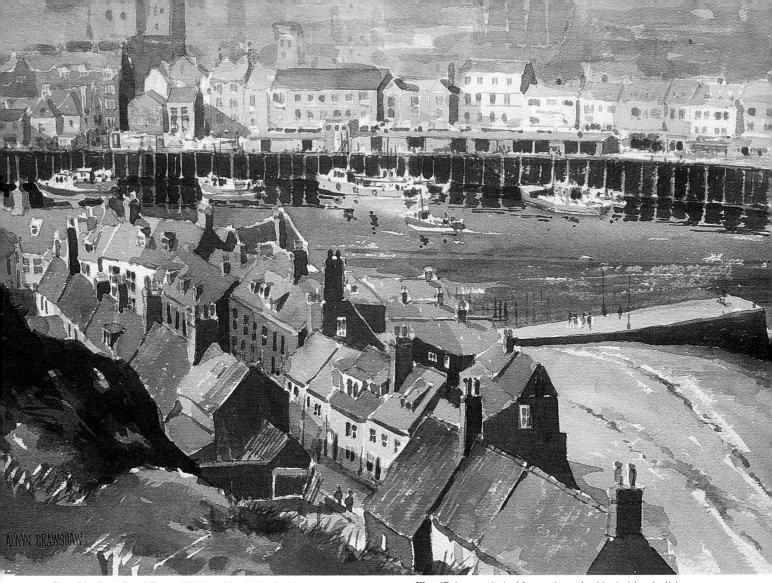

Fig. 66 Red Roof Tops, Whitby, North Yorkshire

quite a bit; on top of that, this was a very complicated picture to draw. Still, it's nice to have a challenge! I painted fig. 66 on Whatman 200 lb Not. The drawing took me about an hour and a half and the painting about two and a half hours. The rest of the family spent the time in the town, shopping, but when I was halfway through the painting and starting to feel hungry, they returned, bringing some food with them. They knew I wouldn't break for lunch, so lunch was brought to the painting spot. Working outdoors under the sun like that, with a wind blowing away the cobwebs, the smell of sea air, and a half-finished painting that was going right, was wonderful.

The pencil sketch in fig. 67 (top right) was the result of a walk on the moors one afternoon. It was very cold so I decided to carry only my sketchbook; my paints as usual were in my waistcoat, in case I needed them. I drew the sketch first, intending to add watercolour on top, but unfortunately the dark sky seen on the left of the picture turned into a snow squall within minutes of finishing the drawing, so no painting was done. Remember, the illustration shown on page 44 and all those in fig. 67 were originally done as impromptu pencil sketches; some were painted after-

Fig. 67 (opposite) Memories of a Yorkshire holiday

wards, where time permitted. The painting in the middle of **fig. 67** is of Helmsley church, and the other church, on the left, is the one where I was christened, in West Yorkshire. The pencil sketch to the right of Helmsley church and the watercolour below left were done as impromptu studies during the week. All the paintings on page 47 were done on 21×29 cm $(8\frac{1}{4} \times 11\frac{1}{2})$ in cartridge paper (the odd shapes are sections of full sketches). The idea of framing your sketches in this way provides a lovely reminder of your holiday and, of course, shows your work to good advantage. Perhaps, in place of one sketch, you could paste in a couple of the holiday photos.

Finally, don't go on holiday with preconceived ideas of what you might be going to paint; the subject matter may be totally different from what you imagined. Go with an open mind and you won't be disappointed. Try not to paint for more than half a day or a long evening at a time, or it will appear that painting is dominating the holiday. Be prepared to make that quick sketch at a moment's notice. Above all, if you are on a family holiday, don't forget there are other family activities going on as well; combine your painting with them. Happy holiday painting.

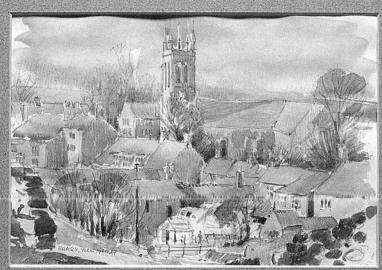

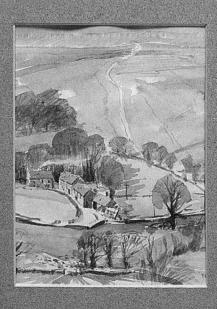

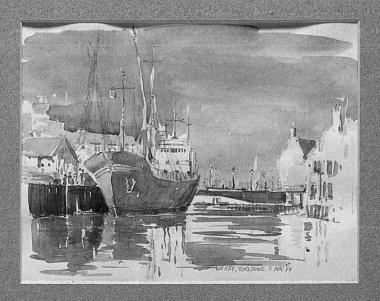

EXERCISE ONE CROCKENWELL

If you have practised the earlier exercises, you will probably feel you are ready to have a go at these more advanced ones. I have tried to explain the methods I used while working on these paintings, but naturally it is impossible to give a complete brush-by-brush account. Before you start painting, read through all the stages and look at the paintings to familiarize yourself with the painting you are going to do. Remember, as you copy my painting, if you feel your own style coming through, let it flourish. Use my painting as a guide only and don't be too concerned with copying it exactly, as this will restrict the development of your individual style. If you have a 'happy accident' which improves the picture a little, keep it.

The first exercise is a painting of a small village in Devon, called Crockenwell. When I did this it was a

bright warm spring day, with the sun casting strong shadows everywhere: a perfect day for painting.

First stage Draw the picture with an HB pencil. Using your No. 10 sable brush, paint in the sky with a wash of French Ultramarine and Crimson Alizarin. As you get near the roof tops add a little Yellow Ochre to your mix. Leave some flecks of white paper, by using the dry brush technique, to suggest the clouds.

Second stage With your No. 6 sable brush, paint in the chimney pots with a mix of Cadmium Red, Yellow Ochre and a touch of French Ultramarine. Paint over the shadow side of the chimney pots with another layer of the same colour. In most cases when you apply your washes, vary the colour mix as you work, as this helps to give character and more life to your

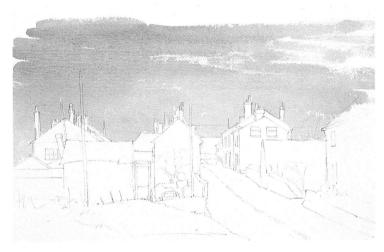

Fig. 68 First stage

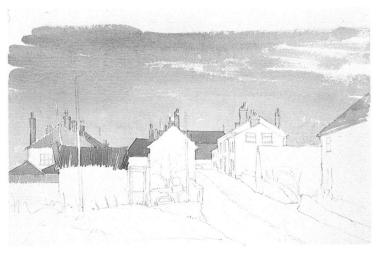

Fig. 69 Second stage

painting. Now mix Crimson Alizarin, French Ultramarine and Yellow Ochre and paint in the roofs of the houses (remember to vary the colours), starting on the left and working to the right. When you paint the corrugated iron roof to the left of the telephone box, work the brush strokes down and leave gaps between some of them to help give the roof a ridged look. Do the same for the roof below and to its left. Leave white spaces for the telegraph poles.

Third stage Continue with your No. 6 sable brush and with a wash of Yellow Ochre only, paint in the house on the extreme left (except for the window) and the one behind the telephone box. Paint through the window in the telephone box, but leaving an area unpainted to give the illusion of glass. Next paint the three furthest houses on the right of the road, making these colours very subtle in relation to one another: the furthest one a watery Yellow Ochre and the middle one French Ultramarine with a little Crimson Alizarin; leave white paper for the third one. Now put in the two dark buildings on the left, using a mix of French Ultramarine, Crimson Alizarin and a touch of Yellow Ochre. Leave white paper at the bottom of

the walls where the grass is growing. Paint in the side of the grey house in the centre of the painting with a wash of French Ultramarine, Crimson Alizarin and a little Yellow Ochre. With the same colours, but more French Ultramarine, paint in the tree, while the wall is wet. Put in the grass underneath the tree, using Hooker's Green No. 1 and a touch of Crimson Alizarin. Add a little French Ultramarine to the mix and paint in the wall on the right of the telegraph pole. With Yellow Ochre and Crimson Alizarin paint the wall behind the white car, and with the same colour but a little extra French Ultramarine, paint the wall at the end of the street. Now put in the telephone box, using Cadmium Red. Paint in the sides of the houses on the right of the road, using a mix of French Ultramarine, Crimson Alizarin and a little Yellow Ochre. Mix Crimson Alizarin, Yellow Ochre and a touch of French Ultramarine and paint the garage roof on the right, adding a little Hooker's Green No. 1 to the mix and suggesting the small tree to the right of the roof. Paint in the low wall on the right with a mix of Yellow Ochre, a little touch of Crimson Alizarin and French Ultramarine. Add a little Hooker's Green No. 1 and paint on top of the wall to represent grass.

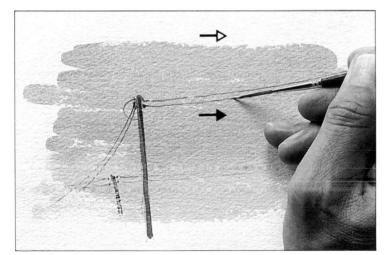

Fig. 70

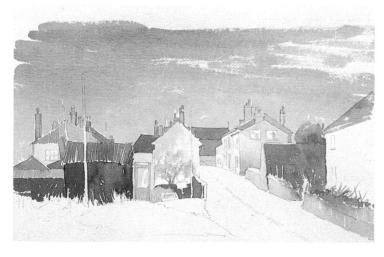

Fig. 71 Third stage

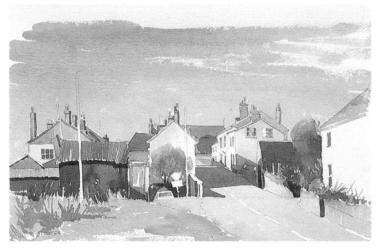

Fig. 72 Fourth stage

Fourth stage Start with your No. 10 sable brush and paint in the road, using Yellow Ochre, Crimson Alizarin and a touch of French Ultramarine. Remember to leave the white lines on the road. Next paint in the left-hand hedge, using the same three colours but much more Yellow Ochre. While this is still wet, continue over the grass with Hooker's Green No. 1, Yellow Ochre and Crimson Alizarin. Use the dry brush technique in the foreground; the resulting flecks of white paper complement the clouds. Now, with your No. 6 sable brush, paint in the windows, using a dark wash mixed from French Ultramarine, Crimson Alizarin and Yellow Ochre. Paint a little more green on the right-hand wall. When the hedge on the left of the picture is dry, paint in the shadow work with your No. 6 sable brush and a darker mix of your hedge colours.

Using the same brush, begin to paint in the shadows of the chimney pots and on the road. Mix a wash of French Ultramarine, Crimson Alizarin and a touch of Yellow Ochre, and start on the chimney pots on the left of the painting, working to the right. With the same colour, paint in the shadows on the gable ends of the roofs and those cast by the two corrugated iron roofs. Put in the suggestion of trees in front of the last house at the end of the road. At this point in the painting I decided to darken the garage roof on the right, using the colours mentioned previously. Paint the shadows across the road next, with a mix of French Ultramarine, Crimson Alizarin and a little Yellow Ochre. Strengthen the telephone box with another wash of Cadmium Red and add some grey tones on its glass. Using a mix of French Ultramarine, Crimson Alizarin and a touch of Yellow Ochre, add another wash to the middle house to the right of the telephone box, thereby giving more prominence to the tree in front.

Finished stage Paint in the two main telegraph poles, using your No. 6 sable brush, with a mix of Yellow

Ochre and a touch of Crimson Alizarin, but leave a white edge (paper) along the left-hand sides. Then, with a dark mix of French Ultramarine, Crimson Alizarin, and a little Yellow Ochre, paint in the remainder of the telegraph poles. Use your No. 2 Dalon brush for the television aerials, overhead electric cables and the birds. Paint in the traffic sign and the shadows from the two telegraph poles. I purposely painted in these shadows at a more acute angle than they actually were as I felt it helped to balance the foreground better. Finally, add any dark accents that you feel necessary to help your painting.

Have you noticed how much I use only three primary colours – French Ultramarine, Crimson Alizarin and Yellow Ochre? Try painting this picture as a half-hour exercise, starting after you have drawn it.

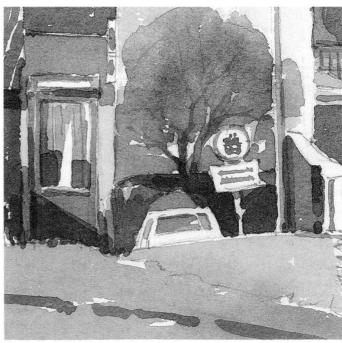

Fig. 73 Detail from finished stage

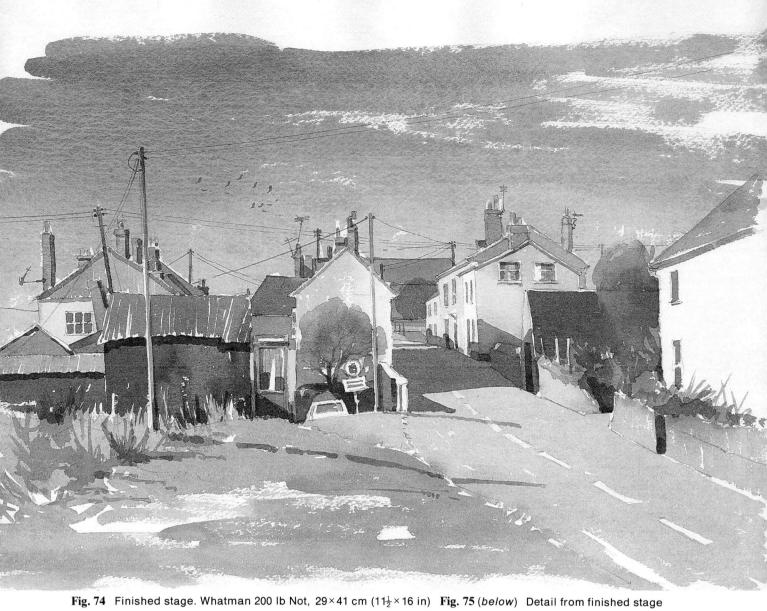

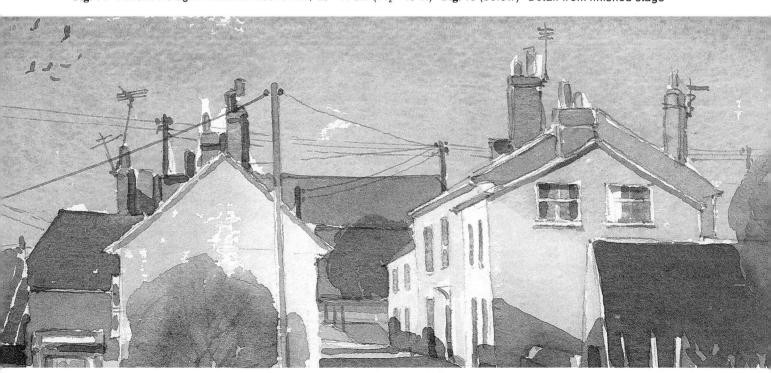

EXERCISE TWO RIVER OTTER

This painting is a typical example of a landscape where a river plays the most important part. In such a case, if the river is overworked the painting could be ruined, so I worked the water very simply as on page 35.

First stage First draw the picture with an HB pencil. Then, using your No. 10 sable brush, soak the paper over the sky area with water. Start at the left side and as you progress to the right, let your brush strokes sweep across the sky. You will find that this technique leaves areas of dry paper which will represent moving clouds. When you paint into the wet areas with colour, they will easily accept the paint, allowing the colours to merge together. The impression of movement has been created by the way in which you use your brush. Use a little Crimson Alizarin for the blue area of sky and add Yellow Ochre for the heavy cloud area on the left. When you reach the hills work in some Hooker's Green No. 1 and a little Cadmium Yellow Pale, and work down the fields on each side of the river; don't worry about the field colours running into the wet sky. For the ploughed field on the left, add more Cadmium Yellow Pale and Crimson Alizarin. Paint round the cows, leaving white paper for them. Paint the pink banks of the river, using Crimson Alizarin and Cadmium Yellow Pale, and then work down your composition, painting in the stones up to the water's edge with the four colours you have used so far. Now let the paint dry.

Second stage Using your No. 6 sable brush and a mix of French Ultramarine, Crimson Alizarin and Yellow Ochre, paint the distant trees and hedges down to the field behind the cows. Let all these dry. Then paint the trees on the left of the river, using your No. 6 sable brush and a No. 2 Dalon brush, with a mix of French Ultramarine, Crimson Alizarin and Yellow Ochre. Next, with your No. 6 sable brush, paint the trunk of the large tree with pale Yellow Ochre (for the sunlit areas only), and then paint the trees using the same colours as for the ones on the left of the picture. When these are dry, paint the darker trees in between them and to the right, using the same colours and brush.

Finished stage Now paint the dark shadows on the two river banks, using your No. 6 sable brush with a mix of French Ultramarine, Crimson Alizarin and Yellow Ochre. Add a little Hooker's Green No. 1 to the bank on each side of the large tree. Put in some

detail work on both banks, by adding shadows to stones and lumps of earth. The sun is on the left and the shadows are therefore on the right side of objects. With your No. 10 sable brush and a mix of French Ultramarine, Crimson Alizarin and a little Yellow

Fig. 76

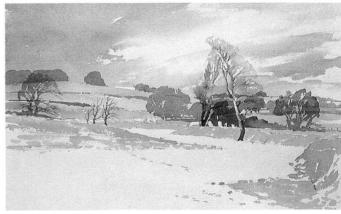

Fig. 77 (centre) First stage Fig. 78 (above) Second stage

Ochre, paint in the water in horizontal strokes, using the dry brush technique. When this wash is dry, use your No. 6 sable brush and the same colours to paint in the reflections. Now paint the cows, using a dark mix of French Ultramarine, Crimson Alizarin and Yellow Ochre; leave unpainted white paper for the white parts of the animals. I toned down the ploughed field on the left of the river at this stage as it was too light in colour. Finish by adding dark tones and accents where you feel it necessary on your painting. If you are not sure what to do, leave it for a few hours, come back later and you will see it with a fresh eye.

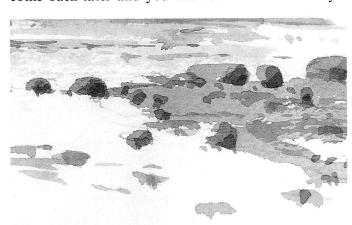

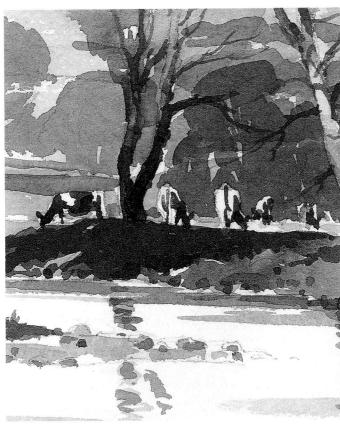

Figs. 79 (above) and 80 (right) Details from finished stage Fig. 81 (below) Finished stage. Whatman 200 lb Not, 35×53 cm (14×21 in)

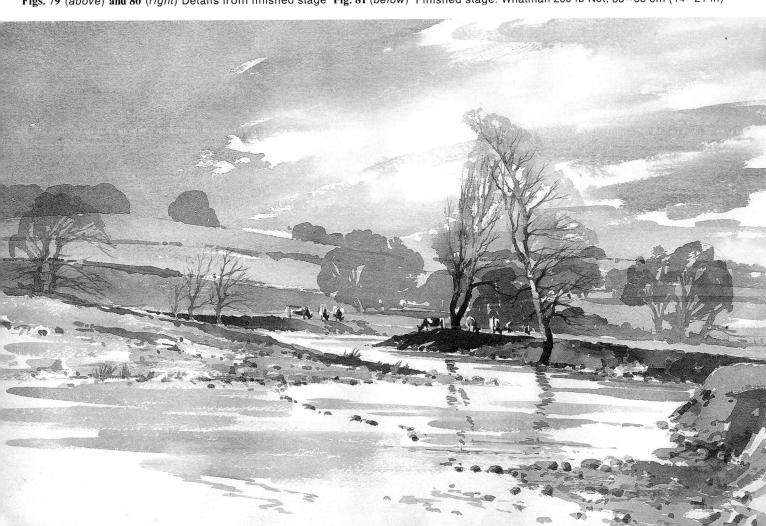

EXERCISE THREE FOUNTAINS ABBEY

When I did the original version of this painting, there was a cold wind blowing and I did not put as much work into it as I have here – done in studio conditions. After I had finished the drawing in my cartridge paper sketchbook (which was a complete drawing in its own right) I found I had enough time and, more importantly, enough warmth left to add colour over the pencil. Incidentally, I feel that the third stage could also have made a good finished painting.

First stage Draw the picture as you would a normal pencil sketch, using a 2B pencil. Then, using your No. 10 sable brush, lay in a wash of French Ultramarine and Crimson Alizarin for the sky. As you get nearer the land add Yellow Ochre to the sky colours. With darker tones of the same wash, suggest the trees to the left and right of the abbey.

Second stage Using a mix of Cadmium Yellow Pale and Crimson Alizarin, paint in the abbey with your No. 10 sable brush. Add Hooker's Green No. 1 to your wash and carry on down the picture, painting in the grass. Now paint the trees to the left, behind and to the right of the abbey, with a varying wash of French Ultramarine, Crimson Alizarin and Yellow Ochre. Then paint the path on the left bank, using a wash of Yellow Ochre, Crimson Alizarin and a little bit of French Ultramarine. Still with the same brush, paint in the water with a wash of French Ultramarine, Crimson Alizarin and just a touch of Yellow Ochre. Next paint the wall with a mix of Yellow Ochre, Crimson Alizarin and French Ultramarine.

Third stage Now you need to put the shadows on the abbey and this is done by applying a mix of French Ultramarine, Crimson Alizarin and Yellow Ochre with your No. 6 sable brush. Start at the top of the tower and work down and to the left, leaving highlights where the sun hits the abbey. With the same colours, using your No. 2 Dalon brush, paint the tree on the far left of the picture.

Finished stage When the abbey is dry, paint the two large trees, using French Ultramarine, Crimson Alizarin, Yellow Ochre and a touch of Hooker's Green No. 1. Work them with your No. 6 sable brush first and then your No. 2 Dalon brush. With your No. 10 sable brush, mix Hooker's Green No. 1, Crimson Alizarin and a little bit of French Ultramarine and

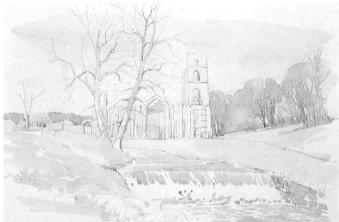

Fig. 82 (top) First stage Fig. 83 (above) Second stage

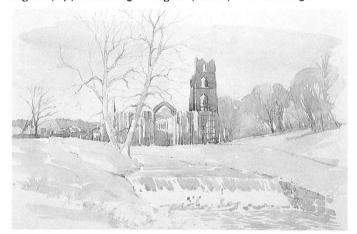

Fig. 84 Third stage

paint in the shadows across the grass areas. Now, using your No. 6 sable brush and the same colours you used for the first wash on the water, paint the reflections of the abbey, keeping them fairly indistinct. Add some darks where the water runs over the waterfall, for the reflection of the right-hand wall, and put in some grass and detail work on the left of the river. Then, still with your dark colour and No. 6 sable brush, paint in some darks on the abbey tower and the scaffolding (there's always scaffolding when I want to

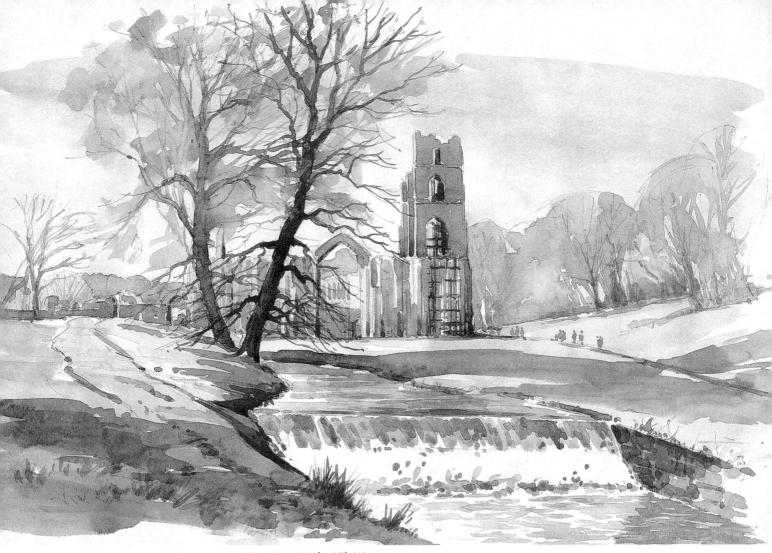

Fig. 85 Finished stage. Cartridge paper, 29×44 cm $(11\frac{1}{2} \times 17\frac{1}{2}$ in)

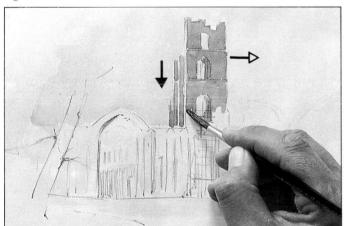

Fig. 86

paint!). Finally, with the same colour, but in a watered-down form, paint the figures on the path leading to the abbey tower.

Whenever you are out painting, always try to find time when you have finished your painting to study the subject for fifteen to thirty minutes; then, when you look at your painting again you will see it with a fresh eye and will often detect parts that could be improved – particularly tonal values. Remember to half close your eyes when looking for tones and shapes.

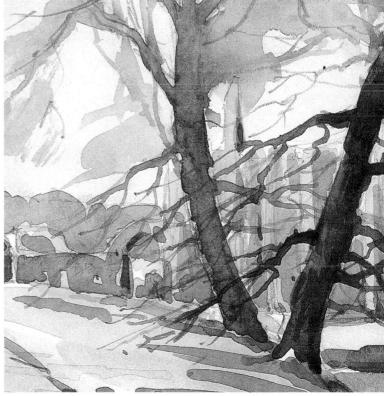

Fig. 87 Detail from finished stage

EXERCISE FOUR FISHING BOAT

I have always been fascinated by boats of all sizes and I love to paint them in watercolour. If one of your natural talents is drawing, you will be able to cope with all types of harbour and estuary scenes, especially ones with lots of boats and detail. If, however, you feel your drawing isn't at its best yet, then practise more before going outside and painting a complicated boat scene. In the meantime, have a go at copying mine. This boat was moored in the River Exe estuary; the tide was up and the water very still. Half an hour before there had been a heavy rain shower – you can see the remains of it moving over the hills in the distance.

First stage Draw the picture with your HB pencil, then with your No. 10 sable brush wet the paper all over except for the masts, boat, and the reflection area of the white and yellow cabin. To prevent areas of your wet paper drying out while you mix your colours, prepare the wash in advance on your palette. Use French Ultramarine, Crimson Alizarin and Yellow Ochre, but when you paint change the colours and tones by adding more colour to your wash. As you paint the wash down the picture, work carefully in between the masts and around the boat. When you paint the water, apply horizontal brush strokes, and use the dry brush technique to work into the areas of reflection. Paint the two right-hand windows of the cabin with the background colour as well.

Second stage Let the foreground wash dry out completely and then paint in the furthest line of hills with a wash of French Ultramarine, Crimson Alizarin and Yellow Ochre, still using your No. 10 sable brush. Continue down to the water, and when you get to the houses on the right, suggest the shapes then let the wash dry. Using the same colours but darker (more colour, less water), paint in the dark hills, working from left to right. Add a few shapes of houses on the left-hand side of the picture.

Third stage Start by mixing a wash of Yellow Ochre and a little Crimson Alizarin, and with your No. 6 sable brush, working from left to right, paint the cabin. Add some French Ultramarine to your wash as you paint the front of the cabin, to deepen the colour and suggest shadow. Now paint in the dark blue of the boat, using French Ultramarine, a little Payne's Grey and a touch of Yellow Ochre. Continue on to the

green part of the hull, using Hooker's Green No. 1, a little French Ultramarine and Crimson Alizarin. Leave a white line between the dark blue and the green. and add more dark on the bows to help give form to the hull. Next paint the yellowy-coloured apron hanging over the side of the boat, using Yellow Ochre, French Ultramarine and a touch of Crimson Alizarin. Paint in the grey board leaning against the cabin with French Ultramarine, Crimson Alizarin and a little Yellow Ochre. Using the same colours, put in the housing for the life belt in front of the cabin and then paint in the large fender with a mix of Yellow Ochre, Crimson Alizarin and French Ultramarine. Using a dark mix of French Ultramarine, Crimson Alizarin and a touch of Yellow Ochre, paint in the two tyres and the shadow area behind the cabin.

Fourth stage This stage brings the boat to life by adding lots of 'bits and pieces' to it in the form of masts, rigging, ropes and so on. The majority of these are worked in dark colours, so make a dark wash from French Ultramarine, Crimson Alizarin and Yellow Ochre, and vary the tones and colours. Start in the cabin, using your No. 6 sable brush, and put in the shapes you can see through the windows. Then work along the boat, painting all the objects that are sticking up above the deck. Use your imagination here; if you were copying from life, you would paint what you saw, but as in this case it is very difficult to see exactly what these objects are, you must improvise quite a bit. Add the shadow cast by the grey board on the cabin wall. Put another wash on the hull, using a mix of French Ultramarine, Crimson Alizarin and a little Yellow Ochre, to give more form to it. Start at the top of the hull near the bows and work down and towards the stern. Next paint in the masts; use your No. 6 sable brush for this, but for the rigging use a No. 2 Dalon brush. The buoy is painted with a little Cadmium Red, using French Ultramarine for the shadow side. Paint in the mooring rope with a mix of Yellow Ochre, Crimson Alizarin and a little French Ultramarine. Using the same colours but with the addition of a little Hooker's Green No. 1, with your No. 10 sable brush paint in the beach in the foreground.

Finished stage With your No. 6 sable brush, paint a little Yellow Ochre into the white reflection. Then, with a strong watery mix of French Ultramarine, Crimson Alizarin, Yellow Ochre and a little Hooker's

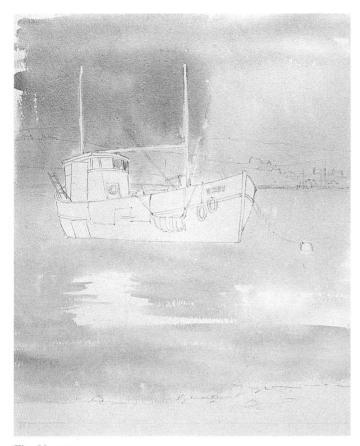

Fig. 88 First stage

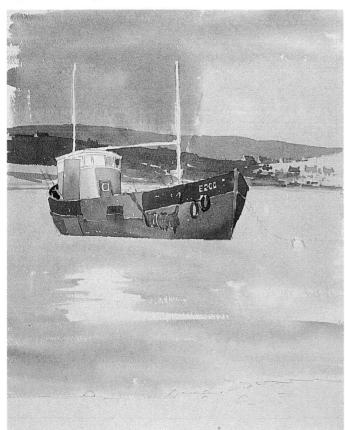

Fig. 90 Third stage

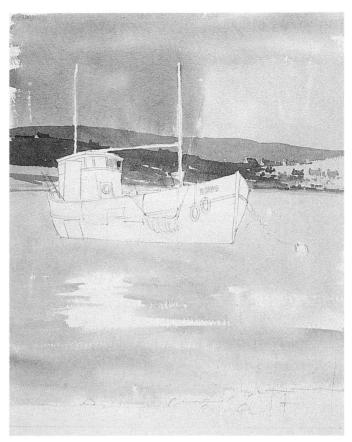

Fig. 89 Second stage

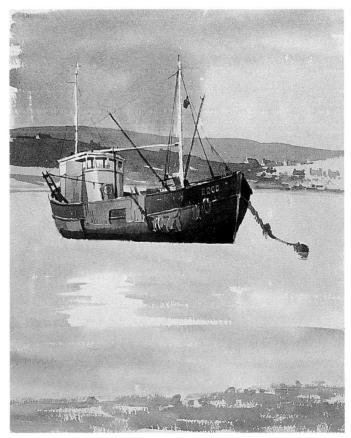

Fig. 91 Fourth stage

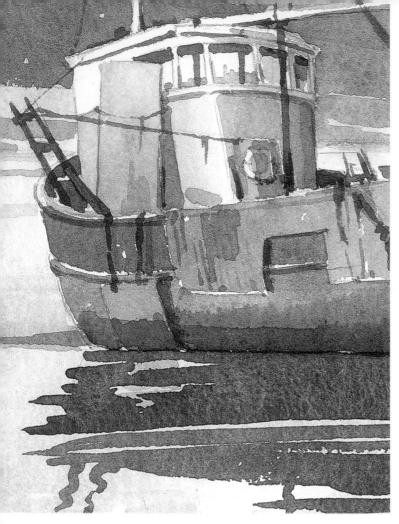

Green No. 1, paint in the reflections. This must all be done in one go to ensure the brush strokes are fluid. Don't try to copy my reflections exactly, or yours will be too rigid. Try to be relaxed. The fainthearted should practise on a piece of spare paper first! With the same colours as before, paint over the water, using horizontal brush strokes to make it appear flat and seem to recede. Finally, work on the beach, paint in the seagulls, and, as usual, remember to look for little areas that need dark accents.

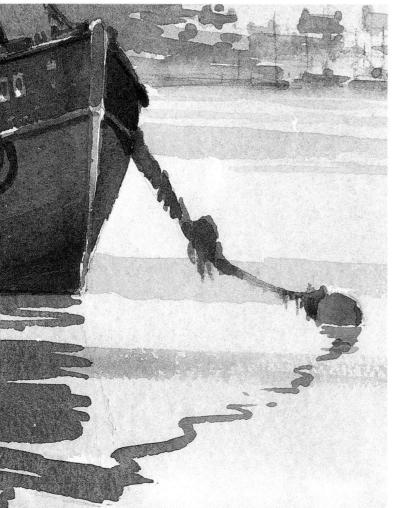

Figs. 92 (left) and 93 (below left) Details from finished stage

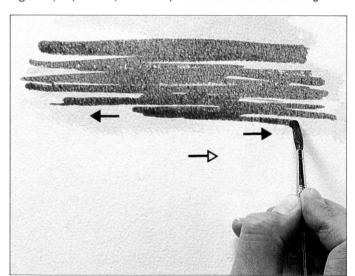

Fig. 94

Fig. 95 (right) Finished stage. Whatman 200 lb Rough, 41×32 cm $(16\times12\frac{1}{2}$ in)

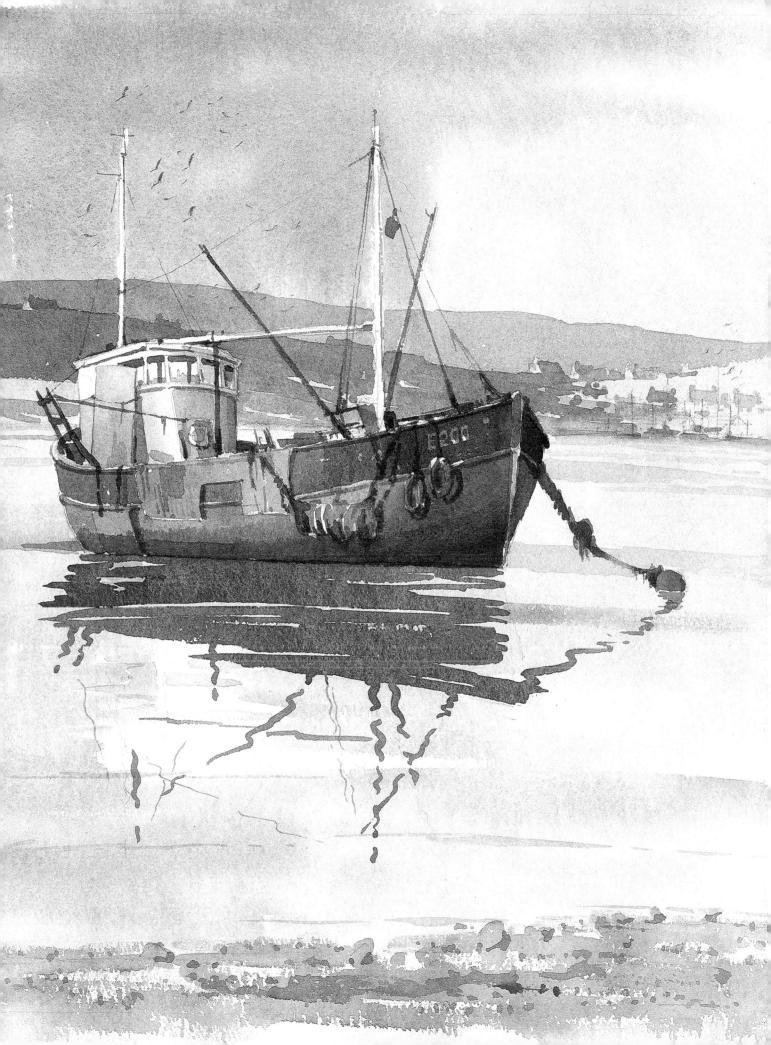

EXERCISE FIVE THE LOCK

Fig. 96 First stage

Fig. 97 Second stage

I have painted this lock, situated on the Basingstoke canal in Surrey, several times in watercolour. The composition contains a combination of soft and hard lines: look, for example, at the recession of hard dark edges from the front lock gate to the less-defined hard edges of the walls - the second gate is much softer and subtly lighter in tone than the front one, and as the canal recedes into the autumn mist, the tonal contrast is very delicately balanced to represent water and trees without the need for any detail at all. I have chosen this picture for the last exercise because I feel it embodies so many of the challenges you encounter painting outside. The techniques required for this composition are varied, ranging from free brush strokes to indicate distance to much more disciplined work for the foreground detail.

First stage Draw the picture with an HB pencil. With your No. 10 sable brush, paint in the sky with a pale wash of French Ultramarine, Crimson Alizarin and a touch of Yellow Ochre, working into the canal banks on each side and over the distant water. Then, with the same colour but a little more Yellow Ochre added, paint the water inside the lock, using the dry brush technique and leaving some white paper showing in the foreground.

Second stage With a wash of French Ultramarine, Crimson Alizarin and Yellow Ochre and still using your No. 10 sable brush, work the trees on each side of the lock. Start with the ones in the distance with a very pale wash, adding more colour as you work forward down the banks. Suggest the tree trunks at

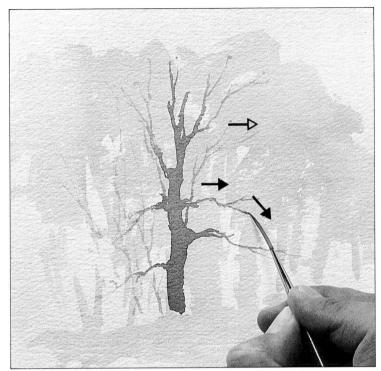

Fig. 98

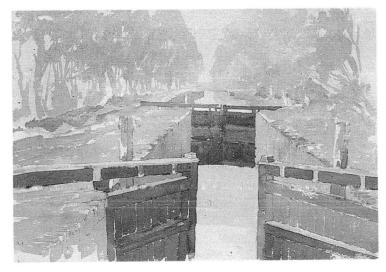

Fig. 99 Third stage

the same time with the same wash. While it is still wet, work the paint, adding Hooker's Green No. 1 and Cadmium Yellow Pale to your mix, on to the canal banks. Use horizontal brush strokes for this to emphasize the flat contour of the banks. Suggest some bricks along the edges of the lock, using Cadmium Yellow Pale mixed with a little Cadmium Red. Using the same colour as for the distant trees, paint in the reflection of the furthest trees on the right-hand side of the canal.

Third stage Continue to use your No. 10 sable brush and with a *pale* wash of Yellow Ochre, Crimson Alizarin, French Ultramarine and a little bit of Hooker's Green No. 1, paint the two sides of the lock. Work your brush strokes vertically from top to

bottom. The sun is coming down from the left-hand side of the picture so the right-hand wall will be lighter than the left. Next use your No. 6 sable brush and mix a strong wash of French Ultramarine, Crimson Alizarin, Yellow Ochre and Hooker's Green No. 1 for the lock gates. You can be reasonably free with your painting of the gates at this stage, as you will be adding more work to them later. Paint them in panels, using down strokes for the wood panels that run vertically and horizontal strokes for the supports that hold these together. Leave small white gaps between the panels to help give form and character to the gates. Remember to vary the colour of your wash slightly as you work, to prevent the gates looking flat and uninteresting. With the same colours, put in the vertical supports on each of the front lock gates.

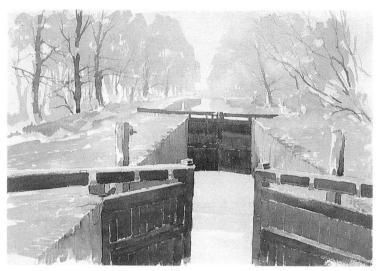

Fig. 100 Fourth stage

Figs. 101 and 102 Details from finished stage

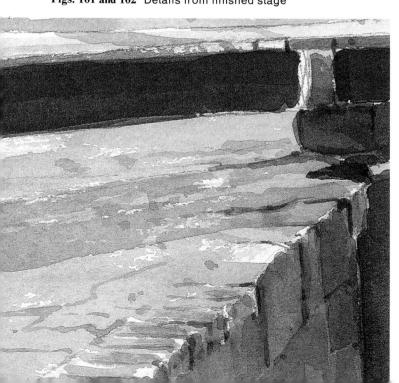

Fourth stage Start with your No. 6 sable brush and a mix of French Ultramarine, Crimson Alizarin and Yellow Ochre, and emphasize the tree trunks and branches on either side of the lock. Keep the paint watery and use your No. 2 Dalon brush for the smaller branches. This will give depth to the trees that you painted in the second stage. Now paint in the shadow on the left-hand lock wall, using the same colours as before, but a little darker. With a mix of French Ultramarine, Crimson Alizarin and a touch of Yellow Ochre, paint a wash over the furthest lock gates; add slightly more water to the wash for the right-hand gate to make it a little lighter. With the same wash darken the walls of the lock near the gate hinges. Now, using your No. 10 sable brush, paint over the nearest lock gates with the same colours.

Finished stage Start by putting in the reflections of the lock gates. Use the same colour mix as for the gates - French Ultramarine, Crimson Alizarin, Yellow Ochre and Hooker's Green No. 1 - and remember to vary it as you work, in the same way as before. Make your wash watery and use your No. 6 sable brush. Work in horizontal strokes, leaving little flecks of the light underwash showing to suggest movement and light, and paint all the reflections in one go while the paint is very wet. Next darken the nearest lock gates, using the same colours as for the reflections. Put in the two posts on the banks by the furthest lock gates and, with the same colours you used for the lock gates and still using your No. 6 sable brush, add a little detail to these gates by suggesting shadows for the main wooden vertical supports. At the same time, when the reflection is dry, drag your brush down to suggest the reflections of a few of these shadows. With the same colour paint in some lines on the left bank to determine the edge of the path. Using a varying mix of French Ultramarine, Crimson Alizarin, Yellow Ochre and Hooker's Green No. 1, work in some detail on the

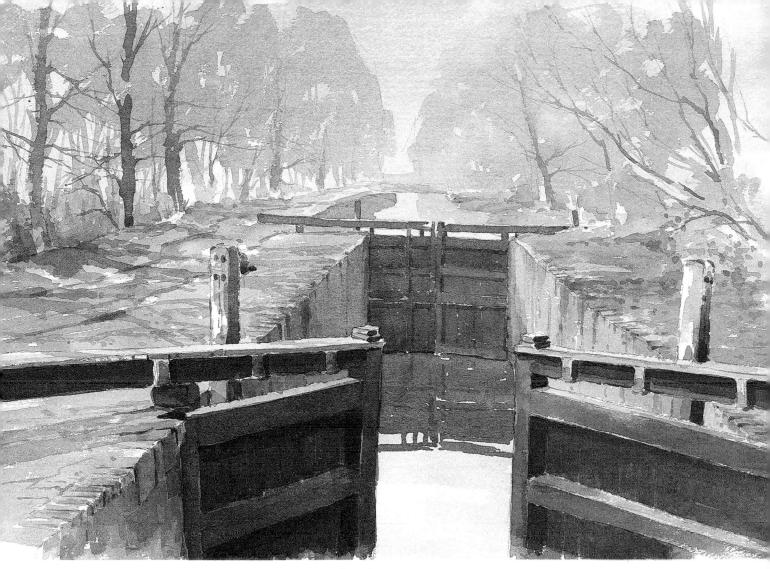

Fig. 103 Finished stage. Whatman 200 lb Not, 29×44 cm $(11\frac{1}{2} \times 17\frac{1}{2}$ in)

banks of each side of the lock. Your brush strokes and tonal patterns must be horizontal to keep the banks flat. Add a little dark to the sides of the nearest left-hand tree to give it a base. Drop some vertical brush strokes down the lock sides, working from the top down, to represent crumbling masonry and weed growth. Paint the shadows cast by the trees across the bank, and the shadow below the arm of the left-hand front lock gate. Work over the bricks again with Cadmium Yellow Pale and a little Cadmium Red, and then paint in some line work to give them detail. Put another dark wash over the nearest gates. Finally, as on all paintings, add any dark accents wherever necessary and put in any extra detail you feel will help your painting.

Well, that is the end of the last exercise and, unfortunately, the end of the book. I do hope you have enjoyed working with the book as much as I enjoyed writing it for you, and I hope that what you have learned will help you to discover and enjoy even more the excitement and challenge of painting out of doors. Good luck.

Fig. 104 (right) Detail from finished stage

DO'S AND DON'TS

Buy the best-quality materials you can afford

Practise mixing colours whenever you can

Don't start your painting without planning it first

Never paint anything in the distance in too much detail

Paint the first scene that inspires you – don't search for a 'better' one

Never place the horizon in the centre of your paper

Observe your subject very carefully

Have confidence in your painting

Make sure you are comfortable when you paint

Half close your eyes when looking for tones and shapes

Don't try to change 'happy accidents'

Always be prepared to make a quick sketch at a moment's notice

Above all, enjoy your painting

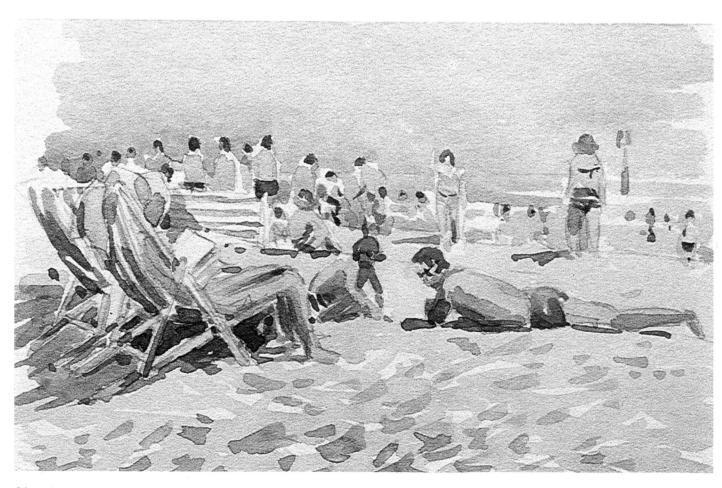